IMAGES
of America

LONG ISLAND
GOLF

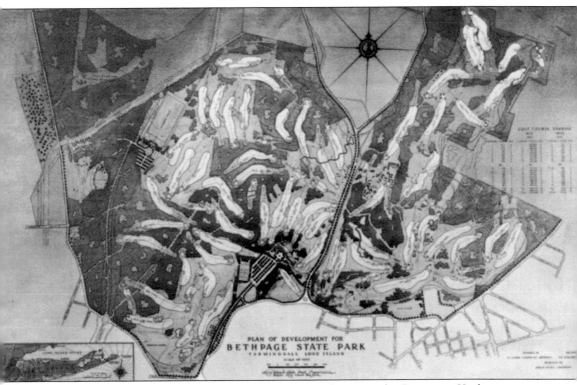

This early map shows how New York State planned to turn the Benjamin Yoakum estate in Farmingdale into a 72-hole golf complex at Bethpage State Park. The existing Lenox Hills Golf Club became Bethpage's Green Course as part of the transformation. The Red, Blue, and Black Courses were all completed by 1936, the result of a massive public-works project that employed as many as 1,800 relief workers. (Courtesy Tillinghast Association.)

IMAGES
of America

LONG ISLAND GOLF

Phil Carlucci

ARCADIA
PUBLISHING

Published by Arcadia Publishing
Charleston, South Carolina

Printed in the United States of America

Library of Congress Control Number: 2014957991

For all general information, please contact Arcadia Publishing:
Telephone 843-853-2070
Fax 843-853-0044
E-mail sales@arcadiapublishing.com
For customer service and orders:
Toll-Free 1-888-313-2665

Visit us on the Internet at www.arcadiapublishing.com

To my family, friends, and fellow Long Island golfers

CONTENTS

ACKNOWLEDGMENTS

Nearly 100 librarians, society members, museum curators, historians, photographers, and writers from across Long Island contributed to this project. Their efforts are greatly appreciated.

The book also relied on the generosity of club managers, members, and representatives from Shinnecock Hills Golf Club, Inwood Country Club, The Woodmere Club, Pine Hollow Country Club, Quogue Field Club, Cold Spring Country Club in partnership with Oheka Castle, and Brentwood Country Club.

Special thanks to historians Phil Young and Bill Quirin, whose insight into the long history of local golf and willingness to answer constant questions made the final product possible.

Special thanks also go to Jim Torre, my grandfather, who showed me, far off the fairway at the Meadow Brook Club during the Northville Classic, that even great ones like Chi Chi Rodriguez need help finding their ball. He took a few nice photographs while he was there too.

Very special thanks to my wife, Suzanne, whose patience and support never waned, even though this project coincided with the arrival of our first child, Rose Palma. And thanks to Rosie. Her uncanny appreciation for a good night's sleep allowed me the time and energy to meet all deadlines.

INTRODUCTION

Centuries passed before the game of golf made its way across the Atlantic Ocean, from Scotland's seaside links to the sandy shores of Long Island. Its transoceanic journey to Shinnecock Hills, America's first incorporated golf club, was set in motion by a previous Atlantic crossing in 1890 that placed three vacationing residents of Southampton in France. William K. Vanderbilt, Duncan Cryder, and Edward Mead met Scotland's Willie Dunn, who addressed their curiosity about the foreign sport in the simplest way possible, with a few practice shots aimed over an abyss at the course he was designing in Biarritz. The Americans were smitten.

"They showed real interest in the game from the beginning; I remember the first demonstration I gave them," wrote Dunn more than 40 years later in *Golf Illustrated*. "We chose the famous Chasm hole—about 225 yards and featuring a deep canyon which has to be cleared with the tee shot; I teed up several balls and laid them all on the green, close to the flag. Vanderbilt turned to his friends and said, 'Gentlemen, this beats rifle shooting for distance and accuracy.'" With that handful of test shots, golf on Long Island was born. The three travelers returned to Southampton with the seeds of a new American sport in hand. First to emerge was Shinnecock Hills.

Golf's appeal was widespread, particularly among the wealthy. Names like Vanderbilt, Whitney, Astor, Belmont, Morgan, and Pratt were attached to many of the newly established clubs. A particularly understated entry in an 1895 issue of the *Brooklyn Daily Eagle* summed up the scene: "The popularity of golf on Long Island is on the increase."

Indeed it was, and within 20 years, some of today's most prestigious American golf clubs were in place. Nassau Country Club and the Piping Rock Club were fixtures, though it took some time for the latter to match its appreciation for golf to its adoration of polo. Historian William Quirin wrote in *America's Linksland* that horses were a common nuisance on Piping Rock's fairways, rankling architect C.B. Macdonald, who was forced to route his course around the polo fields. Garden City Golf Club hosted a US Open and several US Amateurs while still in its infancy, and today, it remains one of the most highly regarded courses in the world. Macdonald's masterpiece, the National Golf Links of America, brought the finest features of British golf to Southampton, literally next door to Shinnecock Hills.

Upon completion of Bethpage State Park in the 1930s, the golf landscape began to look similar to what local players know today. The average player making an average living could spend a day playing 18 holes, just as a wealthy industrialist with a summer estate could play at one of his clubs. Willie Dunn noted this in his 1934 *Golf Illustrated* piece. "A comparison also shows the great progress America has made in golf," he wrote. "In 1895 there were only a handful of courses in the whole country, and only the very wealthy were privileged to play on them. Today there are many hundreds of excellent courses, and those with moderate means may enjoy the game as well as the wealthy."

Dunn's sentiments remain true. On one hand, golf on Long Island is a five-figure initiation fee; on the other, it is a resident rate with a Leisure Pass. Golf on Long Island is an imposing gate

and a tree-canopied entrance road, and it is a starter cutting off a wristband next to a "Warning" sign. It is an elevated tee at The Creek providing a century full of breathtaking bay views, and it is an elevated tee at Heartland Golf Park, bordered by an office park on one side, a mini-golf course on the other, and topped by light stanchions for night play. Whatever the craving and budget, Long Island has something on the golf menu.

Long Island Golf observes the sport through booms like the Roaring Twenties and the Tiger-crazed 1990s, when the wait at the local nine-hole municipal course could be hours long, and there was enough time after check-in to eat a full breakfast and return with time to spare. It also looks at the bust periods, like the post–World War II era, when the lingering strain of economic depression and global warfare was compounded by the mass consumption of Long Island's open, recreational space. Finally, it glances at the sport in the 21st century. Today, Long Island golfers have access to perhaps the greatest variety of classic and modern courses, both public and private, all while the golf industry battles issues like length of rounds and costs to play. Then again, this might not be a new issue. "More often than not, the average golfing day for John Q. Publinx is one of frustration and dissatisfaction. If he is not will to part with an entire day in pursuit of relaxation, he'll have to get to the course of his choice about the time the roosters get tuned up," wrote *Newsday*'s Bill Searby. Of the two-hour waits and "plodding" five-hour rounds, Searby said, "The situation is getting worse instead of better, and there seems to be no solution." Finally, barring government or private intervention, "Long Island's duffers are doomed to a life of snail's-pace, wearisome golf."

That article was published on August 2, 1951.

Most important, *Long Island Golf* looks equally at Long Island's private, public, and long-forgotten golf courses. There are well over 100 golf courses open for play at present, and it is possible that just as many were paved over, plowed over, or refashioned into new ones in the past 125 years.

One

LONG ISLAND'S
FIRST TEE SHOTS

Polo, tennis, foxhunting, and horse racing were already staples of the Long Island club scene when American golf's most influential threesome observed Willie Dunn's demonstration in 1890. Within a year, the American sporting scene changed for good. It did not take long after Shinnecock Hills became America's first incorporated golf club for the game to catch on as both a challenging recreational endeavor and an opportunity for social gathering.

Hotels across Long Island, in places like Massapequa, Amagansett, and Long Beach, traced a series of holes on available land and made them available to guests as a modern-day luxury. Courses emerged and disappeared in Bay Shore, Oyster Bay, Sagaponack, and Sea Cliff. Others started up in East Hampton, Quogue, Bellport, Garden City, and Cedarhurst and live on to this day.

Some simply never existed. According to Oyster Bay town historian John Hammond, many never-built courses were advertised to attract visitors to their towns. When visitors arrived at the Syosset train station in search of the first tee at the Syosset Golf Club, listed in the 1901 *Harper's Official Golf Guide*, they were instead directed to the Oyster Bay Golf Club a few miles away.

In 1905, the *Brooklyn Daily Eagle* billed Long Island as the "Home of the American Game of Golf." "That golf should have spread with such rapidity over the whole of the country is not astonishing to its admirers, and that it should have flourished with exceptional vigor on Long Island is also natural," said the *Eagle*. "Lying as it does at the very door of over-crowded New York, the Island is the natural playground of the city."

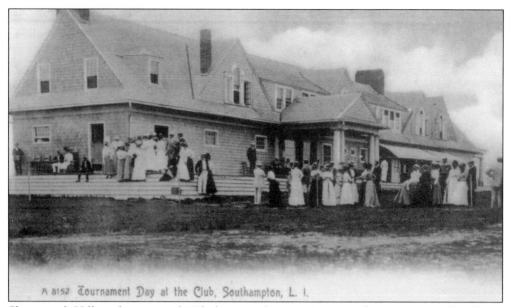

A 8152 Tournament Day at the Club, Southampton, L. I.

Shinnecock Hills and its original 12-hole course became America's first incorporated golf club in 1891. Before its 10th anniversary, Shinnecock hosted a US Open (1896) and US Amateur tournaments for both men (1896) and women (1900). "Society folk" on hand for the US Women's Amateur final in 1900 "came upon aristocratic drags and snappy carts and low, luxurious victorias and they came in droves, too, for it is the biggest sporting event in years in Southampton," described the *Brooklyn Daily Eagle*. (Courtesy Southampton Historical Museum.)

The United States Golf Association was founded in 1894, with Shinnecock Hills one of its five charter members. The club hosted the second US Open, a 36-hole competition played in the shadow of the more prominent US Amateur championship. Scottish pro James Foulis (pictured) shot 78 and 74 to win by three strokes over defending champ Horace Rawlins. H.J. Whigham, one day removed from his Amateur victory, finished seven strokes off the lead. (Courtesy Southampton Historical Museum.)

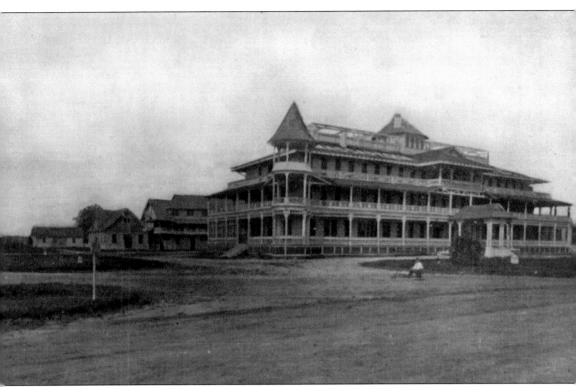

Long Island's south shore was dotted with hotels in the early 1900s, and many built golf courses as deluxe amenities. One of the grandest was the Massapequa Hotel, built in 1888 on Ocean Avenue. Its wraparound porches overlooked a nine-hole golf course, and guests had access to a bathing beach and other modern luxuries. Though the hotel lasted only until 1916, golf continued on the grounds until the early 1950s, when the site was purchased for residential development. Today, the popular All-American Hamburger Drive-In on Merrick Road occupies the northern boundary of the former links. (Author's collection.)

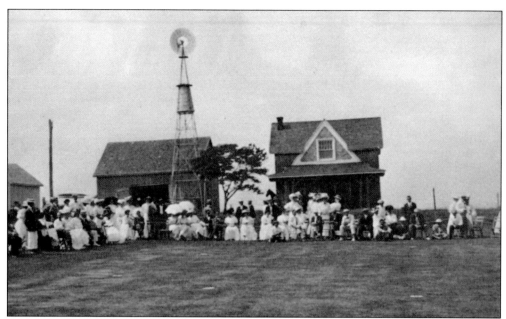

Players and spectators line the green in preparation for a putting contest at Inwood Country Club in 1903. The basic nine-hole course, built over farmland by William Exton and Arthur Thatcher in 1901, would be expanded shortly thereafter and then redesigned by Herbert Strong before entering the international spotlight in the 1920s as host to a PGA Championship and US Open. (Courtesy Inwood Country Club.)

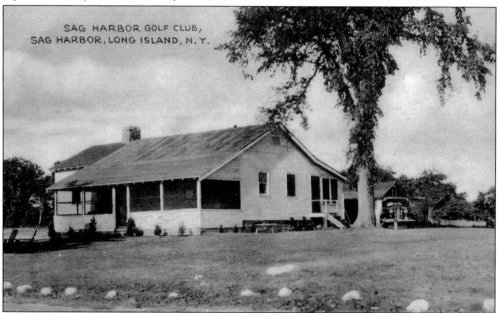

References to golf in Sag Harbor appeared as early as 1899. "The grounds are admirably adapted for the purpose," wrote the *Brooklyn Daily Eagle*, "and several interesting contests have been held with Mr. Fitzgibbons of Westhampton holding the secord [sic] score." Sag Harbor's current course dates to around 1915. For a long time, the course sported sand greens, on which players raked their paths to the cup. (Courtesy John Jermain Library, Sag Harbor, New York.)

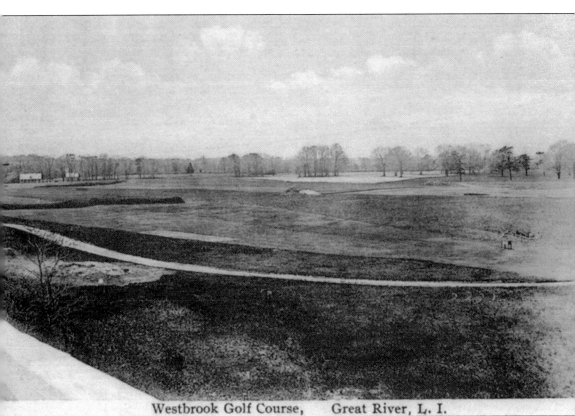

Westbrook Golf Course, Great River, L. I.

Arthur Griffiths left Europe late in the 1890s to become the golf professional at one of Long Island's first golf links, where he would remain a fixture for decades. Westbrook Golf Club in East Islip featured nine holes in the vicinity of today's Bayard Cutting Arboretum. The meticulously groomed Westbrook layout hosted a number of highly regarded players at the end of the 19th century. Walter Travis, Harry Hollins, Findlay Douglas, and other notables competed each year for the Westbrook Cup. Famed female amateur Marion Hollins, winner of the 1921 US Women's Amateur and the driving force behind the Women's National Golf & Tennis Club in Glen Head, got her start at Westbrook. (Courtesy East Islip Historical Society.)

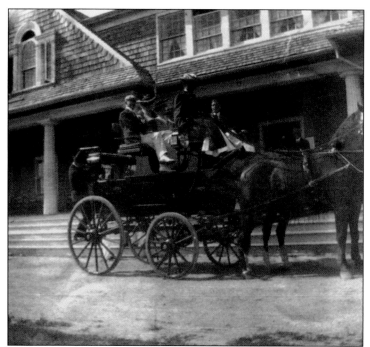

A hired coach arrives at Shinnecock carrying visitors in this 1902 photograph. Renowned architect Stanford White, builder of many iconic structures in New York and around the country, added Shinnecock's clubhouse to his list of achievements in 1892. (Courtesy Southampton Historical Museum.)

Caddies prepare for another day traversing Shinnecock Hills in 1905. Among the club's caddies and course-builders were Shinnecock Indians, and two of them became known for their participation in the 1896 US Open. John Shippen's presence in the tournament nearly caused a revolt, since his father was black. Oscar Bunn, the first Native American to play in the Open, finished far off the lead. (Courtesy Southampton Historical Museum.)

Among the competitors in the 1900 Women's Amateur championship at Shinnecock Hills were, as listed on this photograph, Genevieve Hecker, Mrs. A. De Witte Cochrane, Eunice Terry, Mrs. Caleb F. Fox, Margaret Curtis, and Ruth Underhill. It is not clear who is who in this photograph, and two of the women are unidentified. (Courtesy Southampton Historical Museum.)

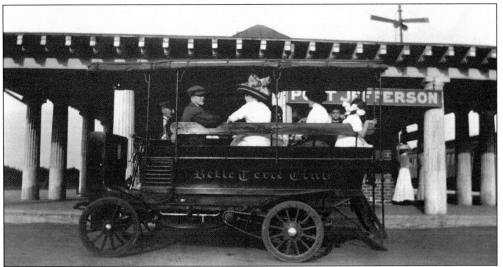

The nine-hole Belle Terre Club opened in 1908 as part of a summer colony that included a luxury hotel, equestrian trails, and stables. Guests who arrived at the Port Jefferson train station were transported to the club by coach. Among the visitors, according to a 2008 *Newsday* retrospective, were the Vanderbilts, Whitneys, and Astors. (Courtesy Kenneth Brady Collection. Now property of the Village of Port Jefferson by gift of deed dated April 30, 2013.)

Golf was first played at the Maidstone Club in East Hampton around 1894. The club had been formed three years earlier, primarily as a tennis destination. A fire destroyed the Maidstone clubhouse in August 1901. The *Brooklyn Daily Eagle* set the scene: "The whole interior was like a roaring furnace with lurid forks of fire coming from the windows and through the roof." Next door at the Maidstone Inn, "affrighted inmates . . . came out after hurriedly dressing, most of the women carrying bundles of valuables done up in sheets and pillow cases." After another fire destroyed the second Maidstone clubhouse in 1922, the current edition rose in a different location near the beach, overlooking the ocean, pool, and cabanas. In this mid-20th-century postcard, players challenge the links course. The English-style clubhouse is in the distance. (Author's collection.)

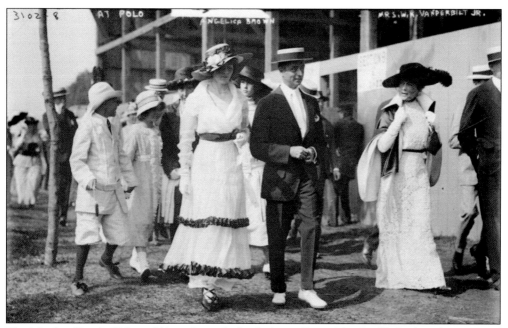

The Meadow Brook Club could have been the birthplace of Long Island golf, if only its hunting and polo-playing members had been a little quicker to come around on the new sport. A demonstration in the late 1880s by British amateur and golf writer Horace Hutchinson left them less than impressed, wrote William Quirin in *America's Linksland*. The demonstration did inspire them to lay out nine holes a few years later. Polo was the primary sport and social event of the day. Above, Mrs. William K. Vanderbilt Jr. (right) arrives for the 1914 International Polo Cup. Golf would start to take hold at the club the following year, when a new 18-hole course was established. (Above, courtesy Library of Congress, Prints & Photographs Division, reproduction no. LC-DIG-ggbain-16308; below, courtesy the Historical Society of the Westburys.)

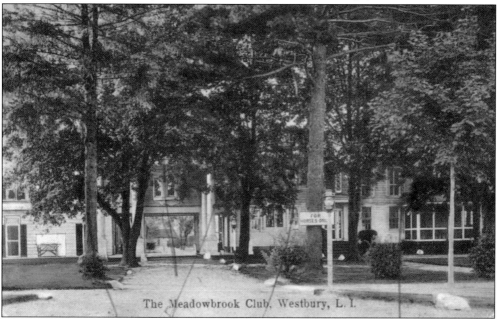

CERTIFICATE OF INCORPORATION

Filed, Queens County, May 12, 1881
Filed, Albany, May 18, 1881

State of New York,
City and County of New York, } ss :

We, the undersigned, August Belmont, Jr., Wendell Goodwin, Belmont Purdy, Frederick O. Beach and Francis R. Appleton, all of full age, citizens of the United States, and of the State of New York, do hereby certify, That we propose to form a corporation of the class known as " Societies for Social, Instructive, Recreative and other purposes," pursuant to the provisions of an act of the Legislature of the State of New York, passed April 11th, 1865, and entitled " An act for the incorporation of societies or clubs for certain social and recreative purposes," and the several acts amendatory thereof and we do hereby set forth :

First.—That the name of said corporation is to be the " MEADOW BROOK CLUB."

Second.—That the object and nature of the business for which said corporation is to be formed is, to support and hunt a pack of fox hounds in the proper seasons, and to promote other out-door sports ; and that the Club house, fixtures and principal place of business thereof is to be at Garden City, in the Township of Hempstead, Queens County, Long Island, State of New York.

17

Meadow Brook's history dates to 1881, when fox hunting was the favored pastime. Golf still had a few years to go before becoming one of the club's "other out-door sports," but once it took hold, it would remain a fixture at Meadow Brook through the club's relocation to Jericho in the 1950s and until the present day. (Courtesy Jericho Public Library.)

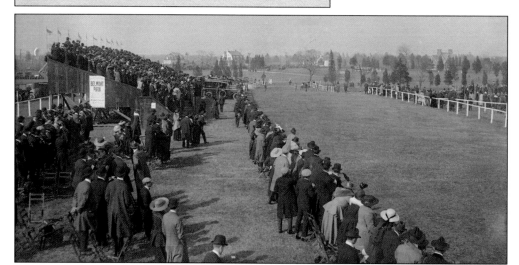

Hunts and equestrian sports predated golf at the Rockaway Hunting Club as well. The club's steeplechase races and polo matches were major sporting and social events, and Rockaway and Meadow Brook would become heated polo rivals. At the time of this racing event in 1916, Rockaway's initial golf course had already been tweaked and extended by Willie Dunn, Tom Bendelow, and Devereux Emmet. (Courtesy Library of Congress, Prints & Photographs Division, reproduction no. LC-DIG-ggbain-21558.)

Decorated amateur and 1915 US Open champion Jerry Travers took up the sport on a short-lived golf course near his home, according to Oyster Bay historian John Hammond. Seen here after his 1915 victory at Baltusrol Golf Club, Travers owed his success on the links to childhood days at the Oyster Bay Golf Club. The Travers estate was within walking distance of the nine-hole course. (Courtesy Library of Congress, Prints & Photographs Division, reproduction no. LC-DIG-ggbain-19325.)

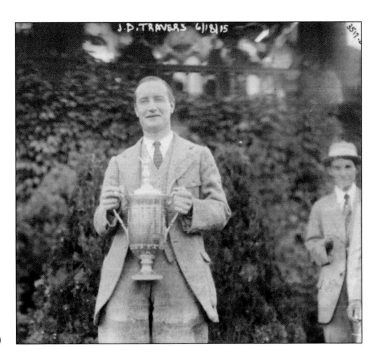

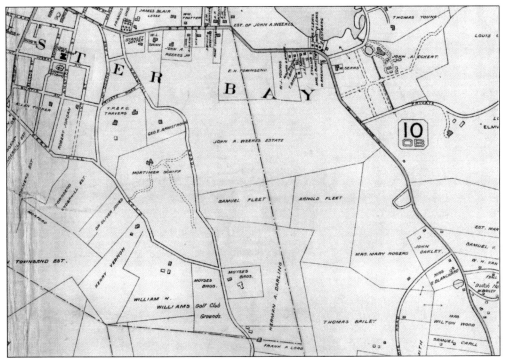

Oyster Bay's course, labeled "Golf Club Grounds" in the bottom center of this 1907 map, was among the earliest to welcome golfers. Theodore Roosevelt was one of them, though he did not enjoy the sport. The course lasted only from 1894 to 1903. The Travers property can be seen northwest of the golf grounds. The course became part of the Mortimer Schiff estate and was used at his leisure. (Courtesy Oyster Bay Historical Society.)

According to John Hammond in *Oyster Bay Remembered*, Jerry Travers set the foundation of his game at Oyster Bay with the help of instructor Willie Mahon. Then, the 14-year-old Travers moved on to the nearby Nassau Country Club and flourished as a protégé of club professional Alex Smith. Nassau's first clubhouse is seen here around 1905. (Courtesy the Glen Cove Public Library, Robert R. Coles Long Island History Room.)

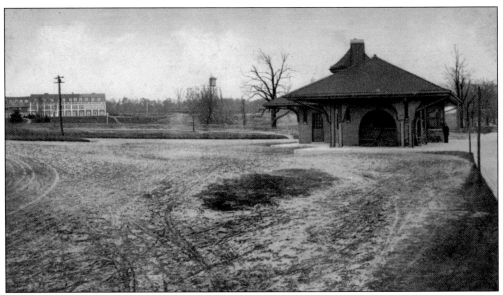

Easy access to railroad travel was vital to golf courses in the 1890s and early 1900s. Nassau Country Club left behind its somewhat remote location on the Pratt estate in 1899 for more accessible grounds beside the Glen Cove train station. Golfers arriving by rail could see the course and clubhouse as soon as they stepped onto the platform. (Author's collection.)

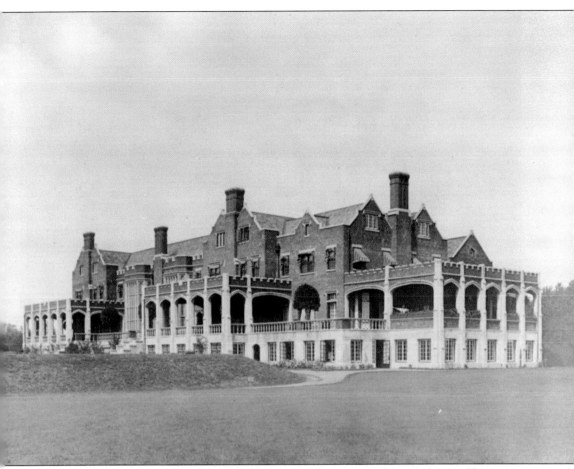

Both a major rivalry and a well-known golf phrase got their starts at Nassau. Pictured here is its current clubhouse, opened in 1910. The club is the birthplace, fittingly, of the "Nassau," a scoring system and popular on-course bet in which the front nine, back nine, and full eighteen each count for a point. Apparently, men of prominence did not want their embarrassing defeats in club matches revealed in humiliating newsprint the following day, so the "Nassau" softened the blow (the worst defeat was 3 and 0). Jerry Travers rounded out his young game at Nassau under Alex Smith's care, and in 1904, he matched up with 42-year-old Walter Travis for the first time. Travers came from behind to defeat Travis in the finals of Nassau's invitational tournament, launching a rivalry that would pit young versus old in seven major amateur contests. (Courtesy the Glen Cove Public Library, Robert R. Coles Long Island History Room.)

When Nassau Country Club moved to its new Glen Cove location, it had to build its course around a Townsend family cemetery dating to the 1700s. The cemetery is located next to what is now the 18th green. The Townsend family sold its farm in 1822, with a clause that the small burial grounds remain as such. (Courtesy Joan Harrison.)

HONORARY MEMBERS

Hon. Calvin Coolidge
Findlay S. Douglas
Hon. Charles E. Hughes
Robert T. Jones, Jr.
Jesse W. Sweetser
Hon. William H. Taft
J. B. Coles Tappan
Mrs. William H. Zabriskie
General R. L. Bullard
Hon. Herbert Hoover

LIFE MEMBERS
(ALSO INCLUDED IN REGULAR MEMBERSHIP LIST)

Percy Chubb
George E. Fahys
Parker D. Handy
Anton G. Hodenpyl
W. Eugene Kimball
Henry L. Maxwell
Howard W. Maxwell
Charles M. Pratt
Frederic B. Pratt
George D. Pratt
Harold I. Pratt
Herbert L. Pratt
Lorin K. Scudder
Christopher D. Smithers
Francis M. Weld
Alexander M. White
Arthur E. Whitney

Nassau boasted an impressive list of honorary members, as seen in this 1929 club book. Bobby Jones and three-time club champion Findlay Douglas undoubtedly traversed the Nassau fairways with more frequency than Presidents Taft, Coolidge, and Hoover. (Courtesy Jericho Public Library.)

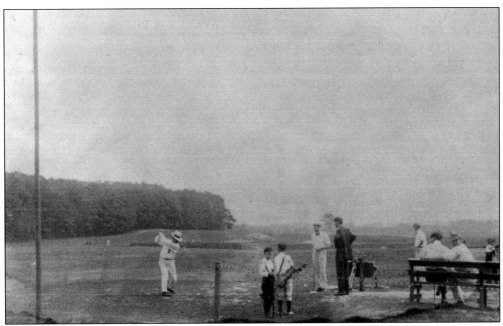

Above, young caddies study a golf swing in motion and a photographer in action at Nassau Country Club. All caliber of players and public figures tested Nassau in its first few decades. Novice members swatted balls from the same tees as Jones, Travers, Travis, Marion Hollins, Ruth Underhill, and Harry Vardon. Boxer Gene Tunney took some hacks at the club. Babe Ruth powered golf balls there with a big lefty swing. (Both, courtesy the Glen Cove Public Library, Robert R. Coles Long Island History Room.)

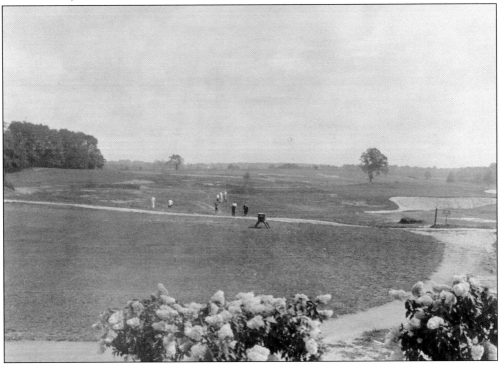

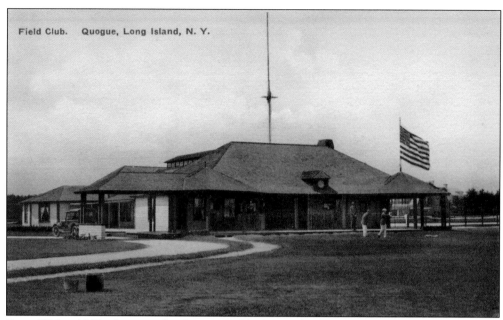

Field Club. Quogue, Long Island, N. Y.

From 1896 to 1900, players at the Quogue Field Club made their way around a nine-hole course designed by R.B. Wilson. Renowned Scottish architect Tom Bendelow built a new nine to replace the original in 1901, and the club has remained there ever since. It would eventually be expanded to 18 holes before returning to a nine-hole setup in the 1940s. (Courtesy Quogue Historical Society.)

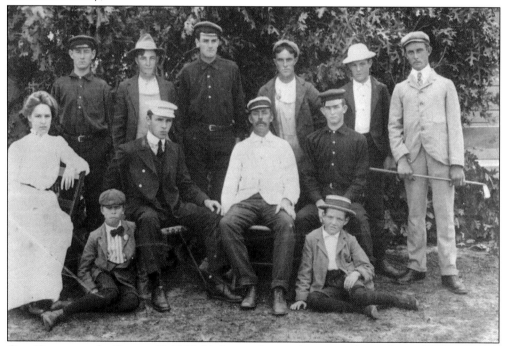

Otto Kammerer, the Quogue Field Club's first professional, poses with members of Quogue's staff in this 1902 photograph. Kammerer is on the far right, holding a golf club. (Courtesy Quogue Historical Society.)

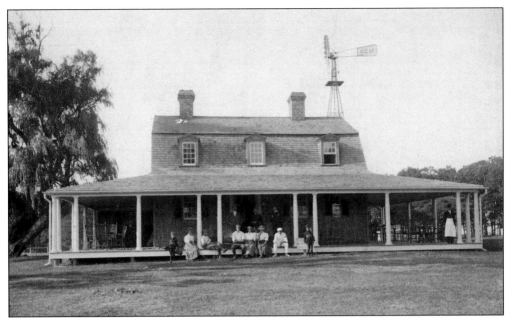

Like Quogue, Shelter Island had its own nine-hole course that opened to curious new players and guests of the Manhanset House hotel in 1896. The golf course was known as Shelter Island Golf Links until 1910, when it was renamed Manhanset Golf Club. (Courtesy Shelter Island Historical Society.)

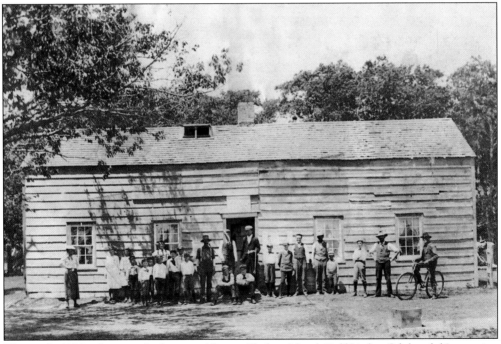

This early-1900s photograph shows caddies at Shelter Island Golf Links. Of the club's opening in 1896, Stewart W. Herman wrote in *The Smallest Village*, "A newspaper announcement noted that the game required 'an attendant to carry a bag of sticks.' Estimated cost: ten cents per boy." (Courtesy Shelter Island Historical Society.)

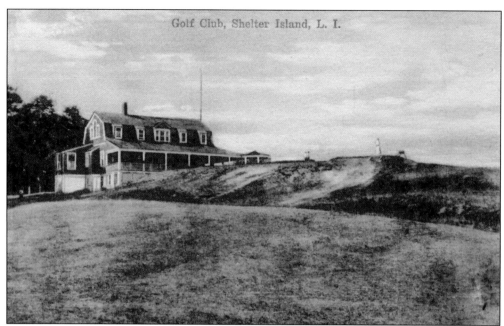

The nine-hole Shelter Island Country Club was built on one of the area's highest points. In time, it would come to be known as "Goat Hill." Its clubhouse was pulled up the slopes by teams of horses prior to the course's debut in 1901. (Courtesy Shelter Island Historical Society.)

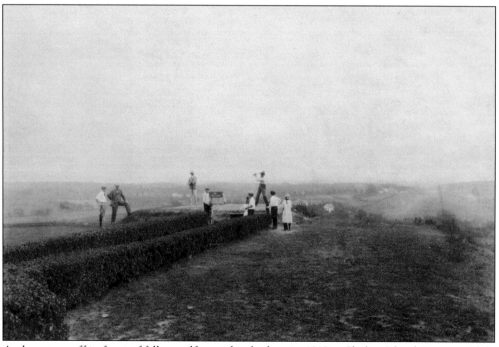

A player tees off in front of fellow golfers and onlookers in 1910 at Shelter Island Country Club. Given the club's lofty perch overlooking the surrounding island, bay, and harbor, there was much more to look at than just one man's swing. (Courtesy Shelter Island Historical Society.)

The hills set up a number of blind shots during the course of a round, but also offered dramatic vistas, like the ones seen in these 1910 photographs. From tee to green, golf balls strained for every yard up the slopes and tumbled down the other sides. Not much has changed since. Today, flags are positioned atop hills to help direct players toward unseen fairways and greens. Due to water-use restrictions, only Shelter Island's greens are irrigated, making the bounces and rolls on the shifting terrain even more pronounced. The club was added to the National Register of Historic Places in 2009. (Both, courtesy Shelter Island Historical Society.)

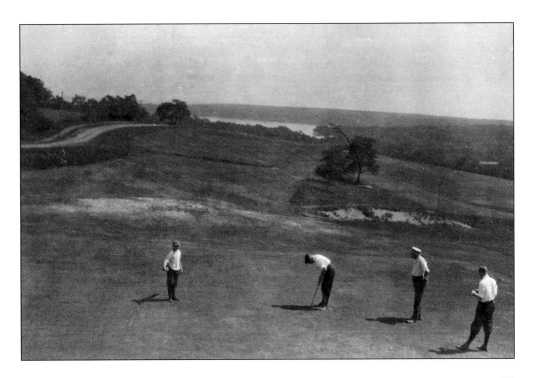

Walter Travis did not take up golf until he was far into his thirties, but once he began swinging, he left a tremendous imprint on the sport on both a local and international level. The Australian-born Travis was a short but extremely accurate hitter with precision around the greens. He steadily improved his game while a member of the Oakland Golf Club in Queens and a fixture at several other New York courses. In 1900, Travis broke through with his first US Amateur victory at Garden City. His contributions to the game reached into the journalistic and design sides of the sport as well. Travis was founder of *The American Golfer* magazine, and he designed or remodeled dozens of courses in New York and along the East Coast. (Courtesy Library of Congress, Prints & Photographs Division, photograph by Harris & Ewing, reproduction no. LC-DIG-hec-01063.)

In addition to his personal exploits on the course, which included three US Amateur titles and a British Amateur win, Walter Travis is best known for his lasting impact at the Garden City Golf Club. A charter member at the revered club, Travis put his own touches on Devereux Emmet's original design, most notably a deep, penal bunker nicknamed in his honor at the 18th green. (Courtesy Library of Congress, Prints & Photographs Division, reproduction no. LC-DIG-ggbain-00467.)

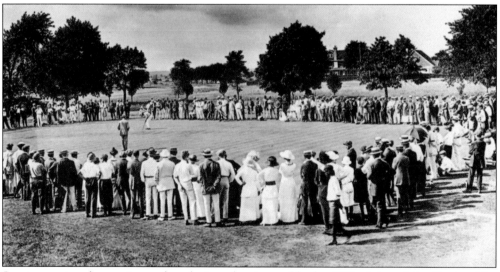

Spectators ring the putting surface during what is possibly the 1910 edition of the Garden City Golf Club's Spring Invitational, in which Walter Travis defeated rival Jerry Travers in the final 2-up. The celebrated amateur tournament would later be renamed for Travis. By 1910, Garden City had already hosted the 1902 US Open, as well as US Amateur championships in 1900 and 1908. (Courtesy Nassau County Department of Parks, Recreation & Museums, Photo Archives Center.)

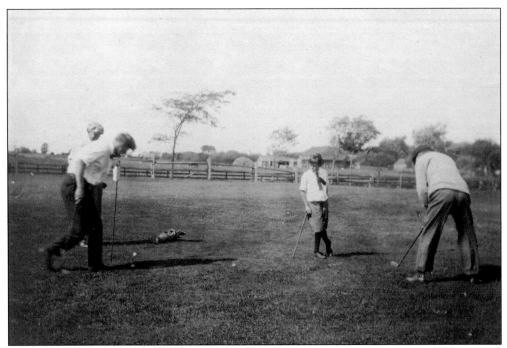

Harper's Official Golf Guide of 1901 lists nine-hole courses close to one another in Bridgehampton, Sagaponack, and Wainscott. Seen here around 1905, golfers young and old take turns putting around a green at Bridgehampton. Bridgehampton still has a nine-hole course; Sagaponack's clubhouse later became an Episcopal church. (Courtesy the Bridgehampton Museum.)

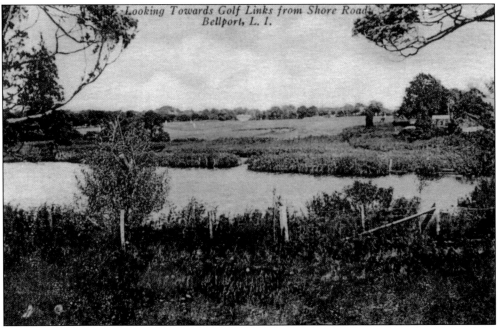

Bellport's original 1899 golf course was laid out west of Academy Lane, near the village center. The bayside course, seen in this early-1900s postcard, was possibly the work of R.B. Wilson, who designed Quogue's initial nine-holer in 1896. (Courtesy the Bellport-Brookhaven Historical Society.)

Like Quogue, Bellport would relocate to roomier space nearby, but not until 1919, when the new Seth Raynor design opened for play. The course welcomed a wide range of players in its heyday, from famous professionals like Gene Sarazen, Walter Hagen, and Jim Barnes, to local novices of all ages. Pint-sized newbies, like the ones seen below, scurried over the same fairways as fellow (though slightly more notable) amateur Francis Ouimet, who played in an exhibition there with Barnes and sportswriter Grantland Rice. The course was sold following a Depression-era foreclosure and was redesigned by Robert Trent Jones in 1961. (Both, courtesy Incorporated Village of Bellport.)

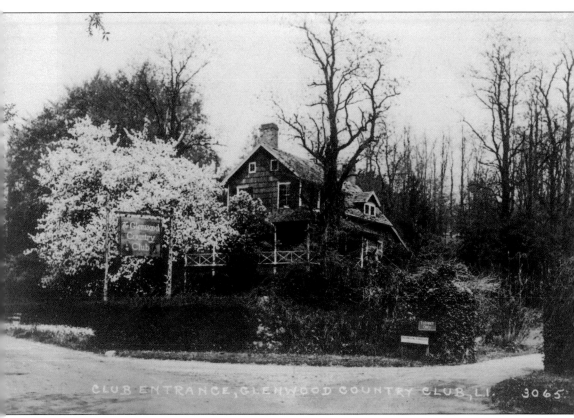

CLUB ENTRANCE, GLENWOOD COUNTRY CLUB, LI. 3065

Expectations were high for the Glenwood Country Club. "In another season the golf course of the Glenwood Country Club at Glen Head should be second to none on Long Island except the National on Peconic Bay and the Garden City course," wrote *Brooklyn Life* in September 1912. Then, eight months later, the same publication claimed, "A more interesting and diversified series would be hard to find anywhere." Within a year, struggling Glenwood was sold and soon became the North Shore Country Club. A brand-new course featured British-inspired replica holes long credited to A.W. Tillinghast. It took until 2009 for the real history to emerge: Seth Raynor and C.B. Macdonald designed the course, not Tillinghast. Among the items found during research, wrote the *Wall Street Journal*'s John Paul Newport, was a thank-you note from the club to Raynor, Macdonald, and superintendent Robert White. (Courtesy Gold Coast Public Library, Local History Collection.)

Two

GOLF'S BIG BOOM

If Long Island was the "playground of the city" in 1905, then it was a full-fledged golfing theme park by the time the 1920s reached full roar. Those immersed in the high times of the Gatsby era needed more places to play when the sun was up—and fast.

Luckily, there was an abundance of open space. By the early 1920s, clubs like Nassau and Piping Rock were long established; relative newcomers included North Hempstead, Engineers, and The Creek. But, there was a thirst for more. *Golf Illustrated* and similar publications advertised pristine land "suitable for golf clubs."

The popularity and appeal of the old and new clubs opened a door for women in the heart of the Gold Coast. Westbrook's Marion Hollins, the 1921 US Women's Amateur champion, was influential in the creation of Women's National Golf & Tennis Club, a home base for female players who were losing access elsewhere as male memberships swelled. Devereux Emmet designed a shot-maker's course that emphasized careful navigation of strategic hazards rather than overwhelming length.

The game changed, however, with the creation of the National Golf Links of America. C.B. Macdonald sized up the state of domestic golf and decided that American golfers needed a true taste of British-style play. It took years of study and surveys, as well as financial backing from wealthy men throughout the country, for his vision to come to life in 1911, right on Shinnecock's doorstep in Southampton. National set a new standard for golf architecture and strategic design. Demand for more work out of Macdonald and protégé Seth Raynor skyrocketed. The result was the creation of renowned clubs across Long Island, including their design and engineering effort at the Lido Club, which briefly joined National and Shinnecock in the upper echelon of American golf.

C.B. Macdonald was among the many designers planning golf courses in the early 1900s, though he was less than impressed with the work of his counterparts. So, he set out to build a course on the East Coast that incorporated many of the notable features found on British links. The result was the National Golf Links of America, a Macdonald/Raynor creation that opened next door to Shinnecock Hills to tremendous accolades. The "trap-sprinkled, bunker-bedecked" layout, as described by the *Brooklyn Daily Eagle*, is considered the earliest example of strategic golf in America. Holes like "Redan," "Alps," and "Eden" were tributes to their European predecessors. Much of the course overlooks Peconic Bay, including its clubhouse. National remains a valuable source of study for golf architects and historians. (Courtesy Rogers Memorial Library, Long Island Collection.)

The Salisbury Golf Club first teed off at its new home near Garden City in 1917. Shortly thereafter, its original course (No. 1) was joined by four others, all Devereux Emmet creations within today's Eisenhower Park. At Salisbury, two of the courses were private, and separate clubhouses on Merrick Avenue served the public players and club members. In 1926, Walter Hagen won the PGA Championship on Salisbury No. 4. (Courtesy Historical Society of the Westburys.)

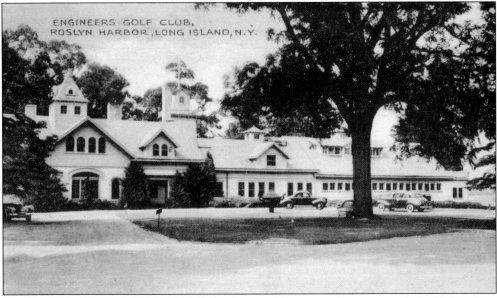

Herbert Strong designed a unique set of holes for a wealthy group of engineers in 1917. Within three years, the aptly named Engineers Country Club hosted PGA and US Amateur championships. While the course received generally high praise, critics derided its collection of blind shots and severe undulations as a "bag of tricks." Among those tricks was the "2 or 20" hole, a short par-3 with a small hilltop green. According to legend, Bobby Jones and Gene Sarazen both scored double figures on the hole. (Courtesy Gold Coast Public Library, Local History Collection.)

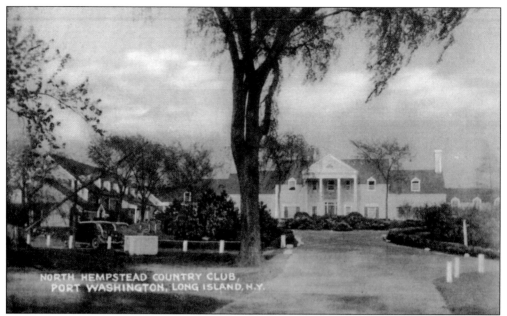

A.W. Tillinghast, Charles Banks, and later, Robert Trent Jones all had a hand in developing the North Hempstead Country Club's course from its debut in Port Washington in 1916. Jim Barnes, whose list of professional achievements includes a PGA Championship won on Long Island turf, became head professional there in the 1940s. (Courtesy Great Neck Library.)

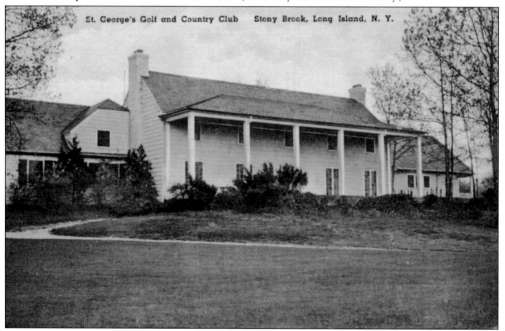

Devereux Emmet left his imprint on all corners of Long Island, beginning in 1897 with Island Golf Links—the original edition of the Garden City Golf Club. He designed a course in his own neck of the woods 20 years later. Emmet's St. George's Golf & Country Club in St. James, marked by undulating greens, spacious sand traps, and unique mounding, opened in 1917 just a few miles from his estate, Sherrewogue. (Author's collection.)

Before his design work down the road at St. George's, Devereux Emmet (pictured right in photograph to the right; the other man may be his son, but it is not confirmed) laid out a course in his own backyard, literally. Sherrewogue, Emmet's home overlooking Stony Brook Harbor, featured a scenic, resident-designed nine-hole course. Below, Emmet stands in front of his 17th-century estate. A talented amateur player and a longtime Long Islander, Emmet's architectural skills were sharpened when he contributed to the planning of the National Golf Links alongside C.B. Macdonald. From there, Emmet designed or remodeled dozens of courses in the metropolitan area, and many of his principles lived on through associate Alfred Tull, who worked the local golf landscape into the 1960s. Emmet is credited with Lenox Hills (later Bethpage Green), Women's National (later Glen Head), Eisenhower Red, Huntington Country Club, and Huntington Crescent Club, among many other current and extinct Long Island courses. (Both, courtesy Smithtown Historical Society.)

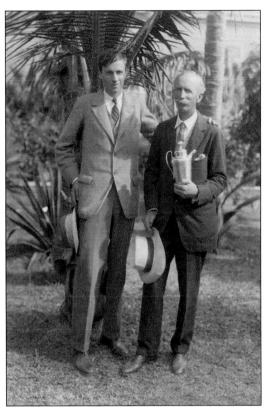

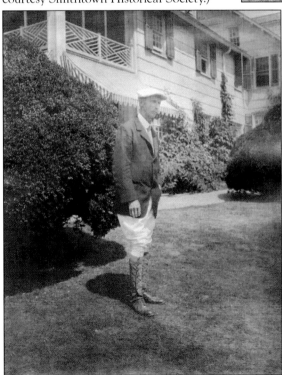

The Case family played a significant role in the development and maintenance of golf in the Cutchogue area. Harrison Case (above, left) helped clear the farmland that would eventually become North Fork Country Club's second nine. Like many Cutchogue kids, Russell Benjamin Case (above, second from left) caddied there from 1918 to 1923. In his autobiography, Russell Case described another rudimentary course fashioned out of an old sheep pasture. Rail fences with sheep wire separated the holes, and tomato cans and old rods or broomsticks stood in for cups and flags. He later established the Cedars Golf Club, a quaint nine-holer that incorporated this pastureland into the upper portion of the course. (Both, courtesy Cutchogue–New Suffolk Free Library.)

Donald Ross is best known for his work crafting North Carolina's Pinehurst Resort, especially the fabled Pinehurst No. 2. Ross designed hundreds of golf courses around the country, yet he did very little work on Long Island. He is credited, however, with the North Fork Country Club in Cutchogue. Charles B. Hudson constructed much of the original nine-hole Ross design on 80 acres of farmland. (Courtesy Tufts Archives, Pinehurst, North Carolina.)

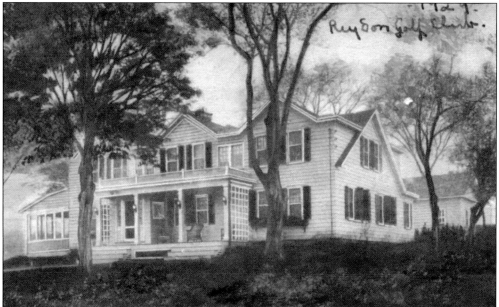

Reydon Golf Club opened in the Bay View section of Southold in 1924. Pictured here is its 18th-century clubhouse. "Its object was to provide at the East End of Long Island a golf course that had more attractive features than any other," wrote Southold historian Dan McCarthy. The club never achieved its grand vision, and offered golf into the 1940s. (Courtesy Southold Free Library, Whitaker Historical Collection.)

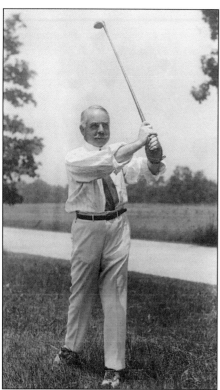

Otto Hermann Kahn amassed tremendous wealth as a banker, financier, and a patron of the arts, so it was only fitting that his Cold Spring Harbor castle, Oheka, twice the size of the White House, was of equal stature. According to golf historian William Quirin, Kahn was denied membership to area clubs because he was Jewish. Kahn responded by hiring Seth Raynor to build a golf course on his 443-acre estate. (Courtesy Oheka Castle.)

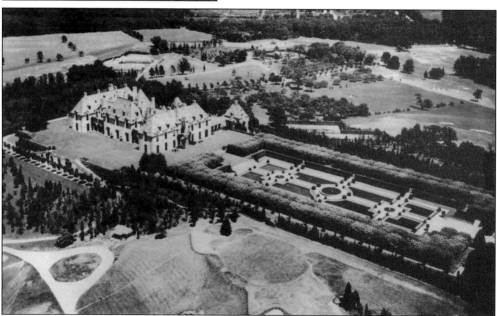

Perched atop a hill, Oheka was a tribute to its chief resident (its name derived from Otto Hermann Kahn's initials). The golf course, like Seth Raynor's previous work at the National Golf Links, was a nod to popular British designs. Legend has it that Kahn would order bunkers built where his guests typically landed their best shots. Parts of the golf course can be seen around the castle in this 1920s aerial photograph. (Courtesy Oheka Castle.)

Young caddies prepare for a loop at the scenic Manhanset Golf Club on Shelter Island. By the time this photograph was taken in 1920, Manhanset—originally the Shelter Island Golf Links—had been extended to 18 holes and stretched from Gardiners Bay to Greenport Harbor. (Courtesy Shelter Island Historical Society.)

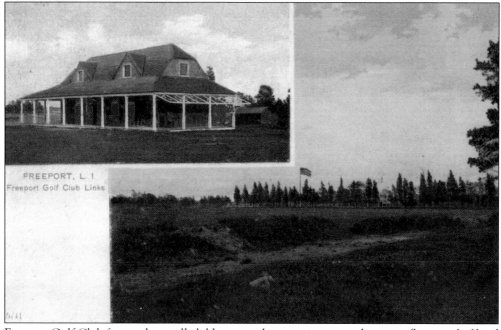

Freeport Golf Club featured a small clubhouse and interesting mounding on a flat parcel of land south of Merrick Road. The course was located east of today's Milburn Park, on a rectangular plot bounded by Brookside and Bayview Avenues. (Courtesy Freeport Historical Museum.)

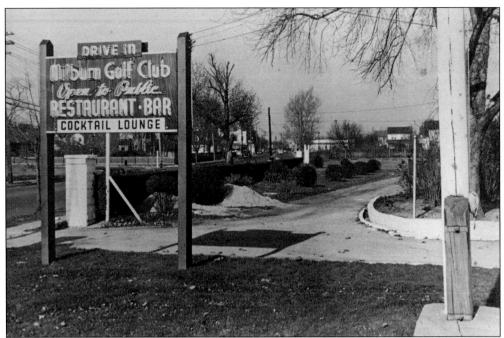

Golfers in the Baldwin area had a local course at the Milburn Golf Club, a private club that went public and was renamed Willowbrook in its later years. The property on Grand Avenue belonged to Hugo Stearns and housed some form of golf links since before World War I. Milburn was organized as a club in 1920, with founding members that included film-industry icons William Fox and Marcus Loew, according to *Newsday*. In the summer of 1919, the *Brooklyn Daily Eagle* previewed the course, which featured "a fine stream that meanders hither and thither about the course like an aqueous wanderer that has no particular place to go and is in no hurry to get there." (Both, courtesy Baldwin Historical Museum.)

LOCAL RULES (cont.)

3. When a ball is played into the brook in playing the 8th hole, or into widened part of brook in front of the tee in playing the 11th, the ball must be dropped on side of brook farthest from hole, and with loss of a stroke.

U. S. Golf Association rules govern all play except as modified by local rules.

In match play, singles, the difference between the handicaps is allowed.
In match play, foursomes, of the difference of the combined handicaps played.
Fractions of ½ or greater count as one; smaller fractions nothing.

It is the duty of every golfer to see that DIVOTS ARE REPLACED and holes for mark filled up.

MILBURN COUNTRY CLUB
BALDWIN, LONG ISLAND, N. Y.

LOCAL RULES

1. When a ball is driven out of bounds or lost, play another ball from where first ball was played, counting all strokes.
Play a provisional ball when first is doubtful.

The following are out of bounds:

(a) In the woods to the left of 3d, 14th, 15th, 16th and 17th.

(b) In or to the left of brook at the 2d and 11th.

(c) Over the fence at the 3d (beyond green), 6th and 18th.

(d) In or beyond brook at the 10th.

(e) In or beyond road at left of fairway and green at 13th.

(f) Beyond out of bound stakes wherever placed.

2. All roads are hazards.

This Milburn scorecard varies significantly from the setup described in the 1919 *Eagle* article, indicating that the course was either rerouted or redesigned during its run. After completing his work at Bethpage State Park, renowned designer A.W. Tillinghast visited Milburn in June 1936 as part of a PGA consulting tour. The course was opened to the public under new owners five years later. Ed Gebhard of *Newsday* wrote that Milburn drew "capacity crowds of golfers" during this time. "The clubhouse is fast becoming one of the most popular dining and partying spots in the county," he added. A 1943 fire destroyed much of the clubhouse, leading to another ownership change and a new life as Willowbrook. (Both, courtesy Baldwin Historical Museum.)

REPLACE DIVOTS

DATE	YARDS	PAR	STROKE	SELF	PTNR.	OP'NT.	PTNR.	WON	LOST	HVD
1	410	4	7							
2	335	4	15							
3	505	5	1							
4	405	4	11							
5	400	4	13							
6	410	4	9							
7	510	5	3							
8	137	3	17							
9	423	4	5							
OUT	3535	37								
10	470	5	2							
11	150	3	18							
12	310	4	10							
13	250	3	12							
14	463	5	6							
15	341	4	8							
16	220	3	14							
17	468	5	4							
18	176	3	16							
IN	2848	35	IN							
OUT	3535	37	OUT							
TOTAL	6383	72	GROSS							
			HANDICAP							
			NET SCORE							

ATTEST:

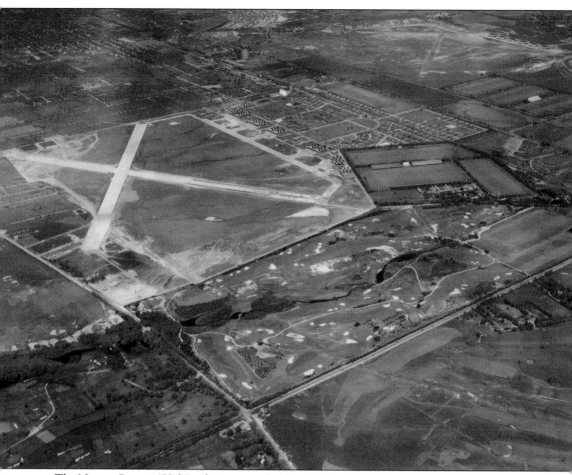

The Nassau County "Hub" today is a popular destination for shopping, dining, and entertainment, but it was once a much-less-congested area marked by airfields and golf courses. Mitchel Field, now the site of Hofstra University, Nassau Community College, and the Nassau Coliseum, occupies much of the terrain in this aerial photograph looking northwest toward Roosevelt Field in the distance. The former Meadow Brook Golf Club plays along Mitchel's eastern perimeter. At bottom right is part of the Salisbury Golf Club. The two courses were separated only by Merrick Avenue. Coldstream Golf Club, built from the East Meadow Brookholt estate, can be seen directly south of Meadow Brook at bottom left. During World War II, Coldstream was taken over by the military and became Camp Santini. (Courtesy Howard Kroplick.)

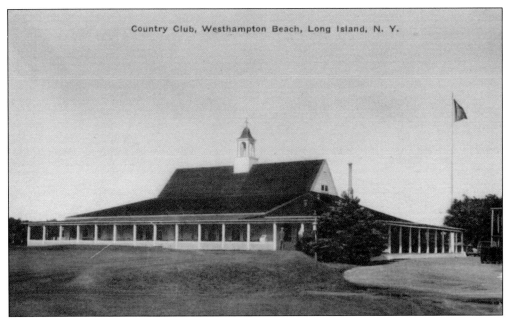

Country Club, Westhampton Beach, Long Island, N. Y.

Westhampton Country Club was designed by Seth Raynor in 1915, though its golf history reaches back to 1895. As golf gained in popularity and social importance, Westhampton added a nine-hole course to the east in Quiogue, which was later replaced by a second course on Beach Lane. As Raynor's more spacious 18-hole layout came to life, the original clubhouse was transported over frozen canals to its new home. (Courtesy Westhampton Beach Historical Society.)

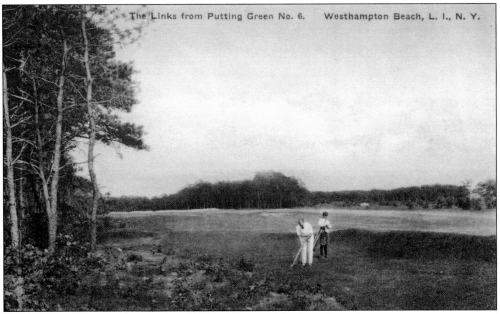

Raynor, who assisted C.B. Macdonald at the National Golf Links in Southampton, incorporated some of his mentor's features into the Westhampton design. By the end of the 1920s, golf's popularity and Westhampton's overall sporting success heightened demand for more fairways and greens. Fittingly, the job of building a second 18 just south of the club went to Charles Banks, an associate of Macdonald's and Raynor's. (Courtesy Westhampton Beach Historical Society.)

The West Hampton Country Club

SUBSCRIBING MEMBERSHIP TICKET

Mr. *S. F. Griffing*

is entitled to the privileges of the Club, subject to the By-Laws and Rules of the Executive Committee, for the following period

1916

W Hirnes Jr.

(OVER)

Griffing was a common name around Westhampton at the time the club was first established. A street in Westhampton Beach bears the family name. Stephen F. Griffing, builder and operator of a spacious, elegant hotel near the Beach Lane links called the Hampton Inn, was a member of the club after its move to the newly designed Raynor course. (Courtesy Westhampton Beach Historical Society.)

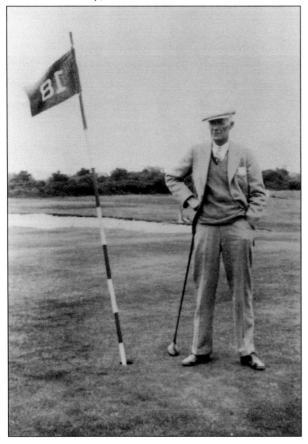

The popularity of golf at the Quogue Field Club's bayside course led to construction of nine additional holes after the 1921 season. The new holes extended west from Tom Bendelow's original nine. George Duffield, pictured here on the new 18th green, was Quogue's professional from 1923 to 1932. (Courtesy Quogue Historical Society.)

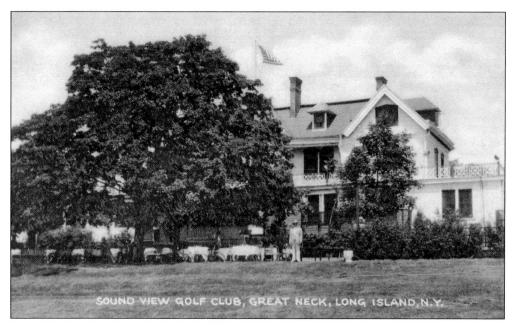

SOUND VIEW GOLF CLUB, GREAT NECK, LONG ISLAND, N.Y.

Prominent figures in entertainment and literature took a particular liking to Great Neck's Sound View Golf Club. "Movie stars of national prominence," wrote the *Evening Telegram*, watched a 1921 "World Series" exhibition pitting US Open champion Jim Barnes against British Open winner Jock Hutchison. "Jim and Jock had to use an awful lot of accuracy . . . to keep from bounding the ball off the bobbed head of a movie actress or two." (Courtesy Great Neck Library.)

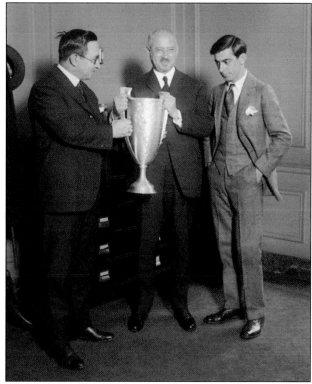

Jim Barnes might never have risen to the unofficial ranks of "world champion" (he beat Hutchison 5 and 4) had it not been for Nathan Jonas, who funded the 1921 exhibition and helped spark interest in "world" competition. The first Ryder Cup took place six years later. Here, Jonas (center) stands beside comedian Eddie Cantor (right), a close friend and frequent visitor at Sound View and Jonas's Lakeville Club. (Courtesy Great Neck Library.)

47

With Long Island's residential boom still decades away, premium land was targeted for more and more prestigious golf clubs during the 1920s. Meanwhile, course architects ranging from up-and-comers to the most in-demand designers advertised their services in golf publications, eager to get to work on the next heralded Long Island projects. Emmet's 1928 advertisement in *Golf Illustrated* (below) includes associate Alfred Tull, who would shape Long Island's golf landscape over the next 40 years. His later work included The Muttontown Club, Indian Hills Country Club, Sunken Meadow State Park's three nine-hole courses, and the Yellow Course at Bethpage. Seth Raynor and Charles Banks also placed notices. Their courses "speak for themselves" said a May 1925 advertisement. A Banks advertisement in February 1927 boasted "Eight Courses Now Under Construction." (Both, courtesy USGA Museum.)

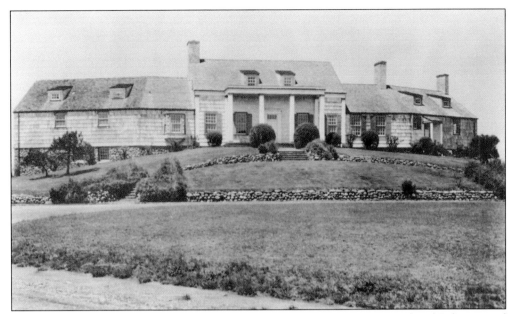

The original Montauk Downs course, designed by Capt. H.C. Tippett as part of Carl Fisher's grand vision for a seaside resort paradise, was a wide-open test that left players and golf balls fully exposed to fierce bay and Atlantic Ocean winds. Set atop a hill, its Colonial-style clubhouse overlooked tumbling terrain reminiscent of a Scottish links. (Courtesy Montauk Library.)

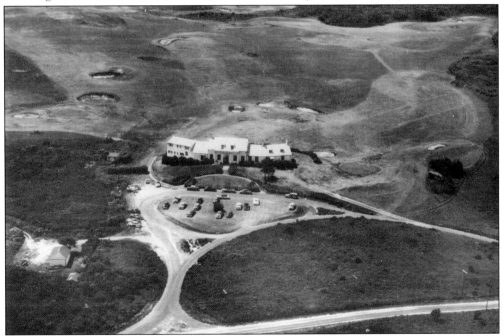

George Trevor of the *New York Sun* described Montauk's "rolling moorlands" in July 1928. "Nature fashioned the Montauk peninsula in the mold of a gargantuan golf links," Trevor wrote. "Thanks to the organizing genius of Carl Fisher and the architectural skill of Capt. Tippett, English course designer, Montauk now boasts of the sportiest eighteen hole links in the metropolitan region. Nature's promise has been fulfilled by man." (Courtesy Montauk Library.)

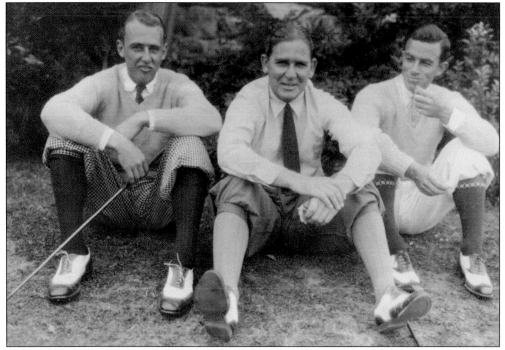

In addition to the wealthy sportsmen lured to Montauk by Carl Fisher's burgeoning development, the course also brought noted amateurs and professionals to the tip of Long Island. Shown here taking a break during a 1929 pro-am are, from left to right, three-time Walker Cup competitor Roland MacKenzie, Australian golfer Joe Kirkwood, and 1928 US Open champion Johnny Farrell. (Courtesy Montauk Library.)

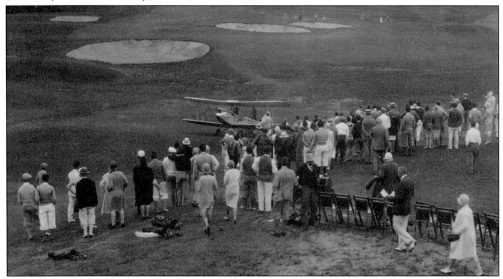

Montauk's treeless layout set up smooth landings for more than just golf balls. Spectators watched as a plane carrying a hasty player touched down on a fairway. "Private airplanes land frequently at Montauk Point, but only occasionally do they land on the course," described *Golf Illustrated*. Based on several newspaper accounts, the player was likely Joe Kirkwood, eager to keep his spot in the 1929 pro-am tournament. (Courtesy Montauk Library.)

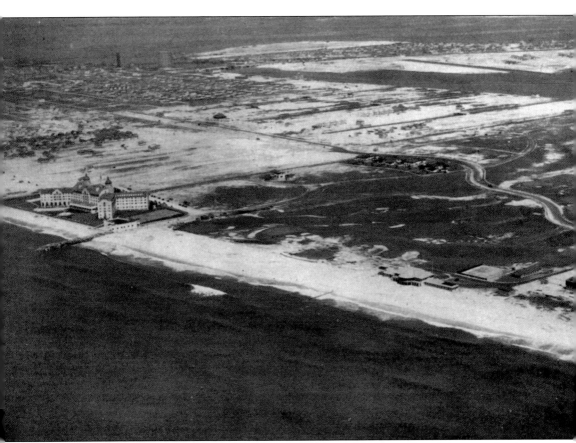

The Lido Club opened for play in 1918 on a remote stretch of the Long Beach barrier island. Creating the links out of a wasteland of sand and swamp was a tremendous undertaking; two million cubic yards of fill were dredged from the bottom of Reynolds Channel to set the course's foundation and the slopes and undulations envisioned by C.B. Macdonald and Seth Raynor. Macdonald was coaxed out of semiretirement by the promise of creative control and free-flowing funds (costs totaled an astronomical $1.43 million) to essentially craft the course of his dreams. He imported Peter Lees from Europe to oversee the vital task of growing grass on sandy fill. In 1928, a new Lido clubhouse and hotel signaled the dawn of a glamorous era along the Atlantic shore. (Courtesy Long Beach Historical Society.)

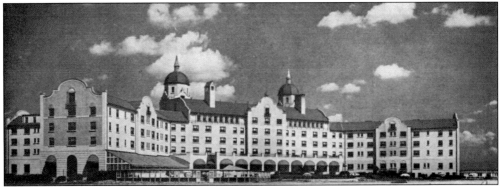

Lido's palatial, pink-hued Spanish Mission clubhouse featured a luxury hotel with a dance floor and oceanfront parasols for guests. It was the "most opulent and magnificent of all the beach resorts of Long Island," declared the *Brooklyn Daily Eagle*. Today, as a condominium complex called Lido Towers, it remains a prominent fixture of the Lido Beach skyline and is the only existing link to the original club. (Courtesy Long Beach Historical Society.)

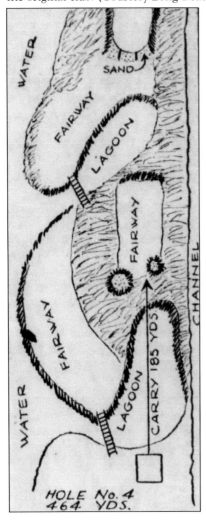

On a course packed with spectacular holes, Macdonald's "Channel" par-5 might have been the best. The safe, roundabout route demanded two accurate water carries. Daring players could instead aim farther out in the distance to an elevated island fairway surrounded by water and coarse brush. (Courtesy Newspapers.com.)

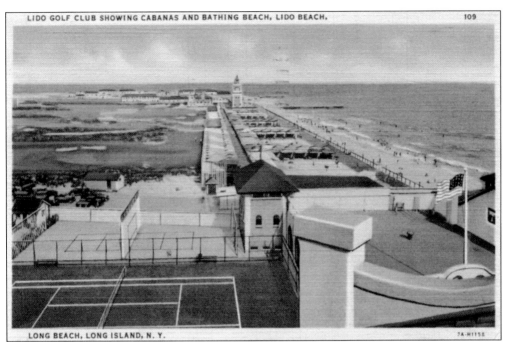

Birdies on Lido's "Ocean" hole were rare, given its location along the Atlantic beach. The treacherous par-3, however, quickly proved too vulnerable to Mother Nature. Frequent modifications turned it into a shadow of its original self. Eventually, it was "tucked away" behind a half-mile of cabanas, as seen in this 1935 postcard. The *Brooklyn Daily Eagle*'s Ralph Trost decried the hole's location "in a lee spot that is stifling hot and where the winds whistling above can never be felt, but only guessed at." (Author's collection.)

Lido's various amenities are highlighted in this late-1930s aerial photograph. Macdonald's and Raynor's course, by this time nipped, tucked, and remodeled to suit real estate interests, according to *The Evangelist of Golf: The Story of Charles Blair Macdonald*, carries on behind the cabanas. Visible at upper left are tees that aim over Lido Boulevard toward the channel side of the course. (Courtesy Long Beach Historical Society.)

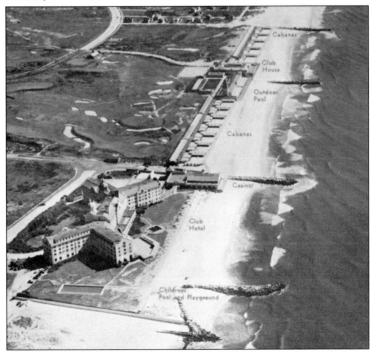

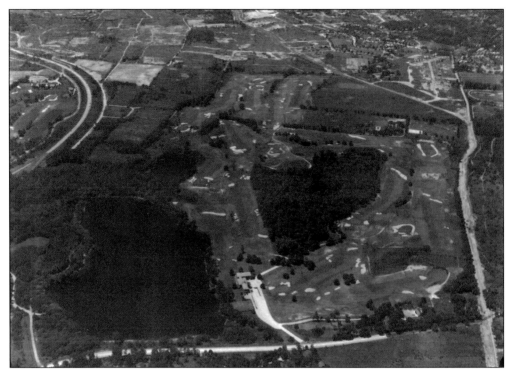

Deepdale Golf Club, seen here at its original location in 1936, was another Macdonald/Raynor/ Banks product, built for William K. Vanderbilt Jr. on his summer estate. The club moved to a new course nearby in the 1950s, when construction of the Long Island Expressway destroyed part of the original. Lake Success Country Club now occupies what remains of the site. The former Glen Oaks Club (now Towers Country Club) can be seen on the left. (Courtesy the Society for the Preservation of Long Island Antiquities.)

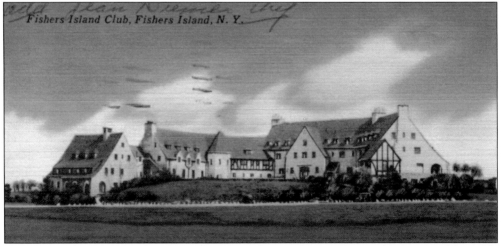

Fishers Island Club, Fishers Island, N. Y.

Seth Raynor developed another course by the sea, about as far away from Lido as one could possibly go on Long Island. The Fishers Island Club near the Connecticut coast opened just months after Raynor's death in 1926. In *Golf Clubs of the MGA*, William Quirin wrote that Fishers Island's original clubhouse was so large that it resisted an attempted demolition by explosives in the 1960s. A fire eventually brought it down. (Author's collection.)

Second Hole Southampton Golf Club, Southampton, Long Island, N. Y.

C.B. Macdonald originally hired Raynor, a local Southampton surveyor with no golf experience, to map the land for his National Golf Links. Raynor proved to be proficient in the engineering of golf courses, so he embarked on a new career working beside Macdonald and eventually on his own. After building a number of courses on and off Long Island, Raynor returned home in 1925 to design the Southampton Golf Club, a short jaunt from both National and Shinnecock. Many of his signature features were softened or eliminated over time, but a 2010 restoration brought Raynor-style putting surfaces and bunkers back to life. (Both, courtesy Southampton Historical Museum.)

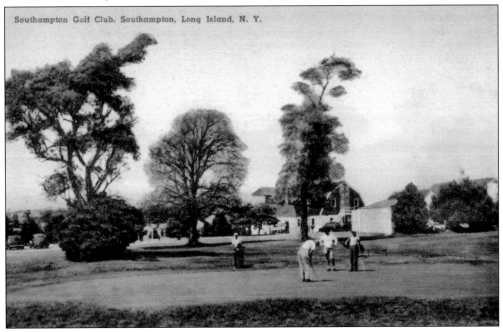

Southampton Golf Club. Southampton, Long Island, N. Y.

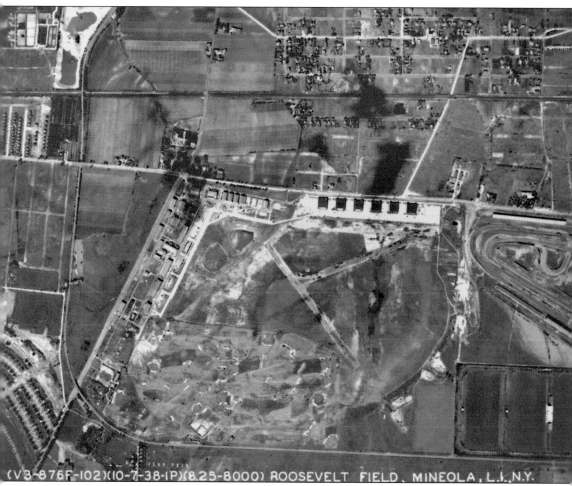

(V3-876F-102)(10-7-38-1P)(8.25-8000) ROOSEVELT FIELD, MINEOLA, L.I.,N.Y.

Long before it was a sprawling shopping complex, Roosevelt Field was a military and civilian airfield. Charles Lindbergh's famed transatlantic flight lifted off from there in 1927. As airplanes climbed and descended over Roosevelt's runways, golf balls mimicked their flights, rising and landing on the fairways of the Old Westbury Golf Club. In a preview of what was to come during Long Island's future residential era, the next-door neighbors frequently fought over a fence. The club had grown tired of low planes buzzing its members and, worse, crashing onto its course. So, Old Westbury built a fence along the shared boundary to force Roosevelt Field to reroute its planes. Seen at right in this photograph are Roosevelt Raceway and the Meadow Brook Club's polo fields. (Courtesy Howard Kroplick.)

Three

DEPRESSION AND DISASTER

The glitz and glamour that marked the Roaring Twenties faded before the decade came to an end, replaced by the gloom and unfathomable hardship brought on by the stock market crash and the Great Depression. It was only natural that golf, tied to high society and the era's financial movers and shakers, would suffer as well.

Over the next two decades, a series of events, some international in scope, some exclusive to Long Island, would separate the hardiest golf facilities from the flawed. A number of courses and clubs that were not completely devastated by the effects of the Depression were severely weakened. The next heavy blow would likely knock them out for good. Others suffered from horrible timing, opening at the tail end of the boom period, when the gloom was nowhere in sight.

Unfortunately, those blows eventually landed. On September 21, 1938, a hurricane later dubbed the "Long Island Express" for its incredible speed arrived with little warning and pummeled the East End. The damage from Westhampton to Montauk was enormous.

Once the war effort began in the 1940s, golf became more of an afterthought. Courses were abandoned, neglected, sporadically attended, or faced with foreclosure. In some cases, fairways and greens took a trip back in time to their previous lives as agricultural land. On Shelter Island, the Manhanset course was used to grow lima beans. Amagansett Golf Club sprouted potatoes.

World War II had a direct impact on one golf course, in particular. The Navy needed barracks and drill areas on the south shore, and the Lido Club's massive hotel and open seaside land fit the bill. The club was leased to the Navy, which wasted little time in leveling the windswept grounds and its distinctive holes and topography. C.B. Macdonald's masterpiece, considered by many to be among the country's greatest courses, was history.

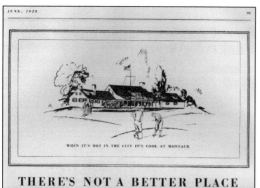

Carl Fisher, builder of Miami Beach, envisioned Montauk as balmy Florida's summertime alternative, a luxurious resort complete with a posh hotel, golf course, tennis, polo, and yachting. Fisher purchased 9,000 acres of oceanfront and bayside real estate and began making his vision a reality, starting with the glamorous Montauk Manor Hotel and the Montauk Downs golf course in 1927. The stock market crashed two years later, and much of Fisher's dream failed to materialize. (Courtesy USGA Museum.)

In the late 1920s, eastbound travelers would take the brand-new Southern State Parkway to reach Long Island's south shore destinations. One of the first landmarks east of the Queens-Nassau line was the Valley Stream Country Club, which bordered the roadway at Franklin Avenue. With the Depression in full force, this 1932 advertisement painted the course as a welcoming destination for those who could still swing the clubs amid financial hardship. (Courtesy Brooklyn Public Library.)

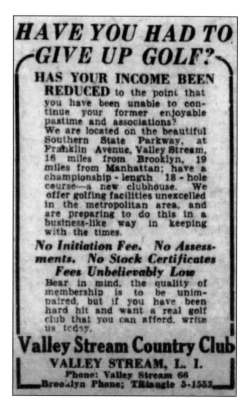

Charles Banks entered the golf-design field as an associate of Macdonald and Raynor, so it was fitting that he would follow in Raynor's footsteps at Westhampton when the club sought to expand. His bayside Oneck course debuted, unfortunately, at the same time the Depression was setting in. Lots along the perimeter were up for sale in 1930. By 1933, the club stopped maintaining the course and eventually left it abandoned. (Courtesy Westhampton Beach Historical Society.)

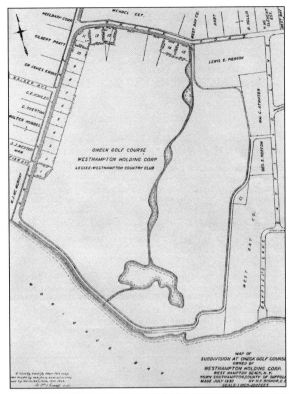

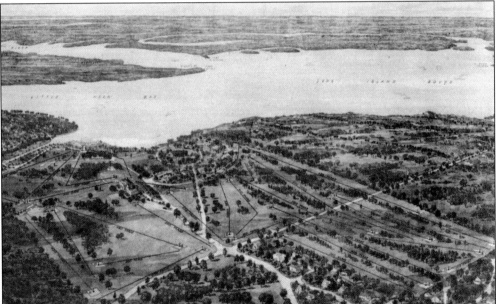

Unlike Westhampton, the Sound View Golf Club in Great Neck never got as far as actually building its additional 18. The club had lofty goals, among them a second golf course beside Little Neck Bay, as seen in this artist rendering, as well as a "beach casino" and other luxuries. Few, if any, of the planned improvements ever came about. The club was sold for the development of Great Neck Estates in 1945. (Courtesy Great Neck Library.)

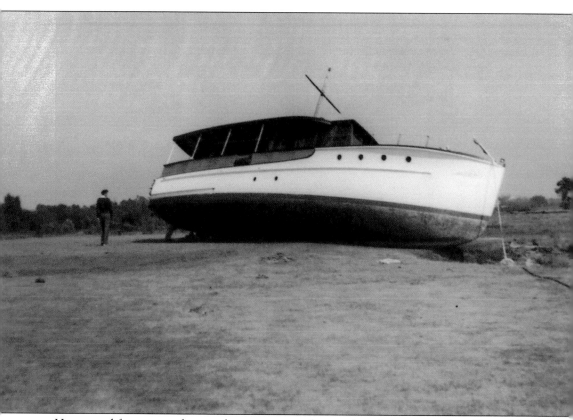

Homes and farms were destroyed, streets were submerged, and the geography of Long Island's south shore was permanently altered when a hurricane, the "Long Island Express," pummeled the East End on September 21, 1938. The devastating storm barreled into Suffolk County's south shore in mid-afternoon with little warning. Though it was merely "a big rain" for many points to the west, according to the *Brooklyn Daily Eagle*, Westhampton absorbed an especially hard blow. Twenty-nine people died in Westhampton, which sat in perilous position immediately east of the storm's center. The vast majority of homes near the beach were obliterated. Boats, buildings, and cars were tossed and turned for miles. Main Street was submerged by as much as eight feet of water. Here, a displaced yacht sits askew on the grounds of the Westhampton Country Club, its anchor at rest in a course bunker. Westhampton's clubhouse was temporarily repurposed as a morgue in the storm's aftermath. (Courtesy Westhampton Beach Historical Society.)

The storm demolished two bridges that connected the Quogue mainland to the beach. A single bridge replaced them, and its access road was extended through the center of the Quogue Field Club's back nine. The club tried to work around this new and intrusive course feature, but, ultimately, Quogue would return to its original nine-hole setup after World War II. (Courtesy Quogue Historical Society.)

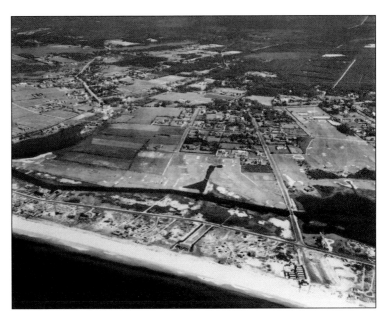

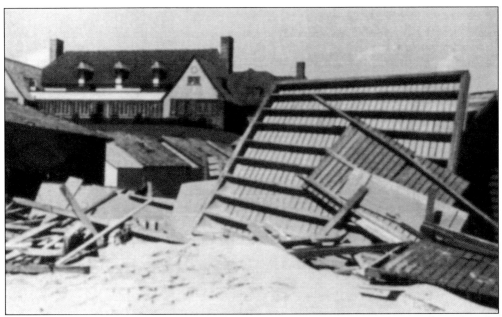

The Maidstone Club was "battered to pieces," as described in the *Brooklyn Daily Eagle*. The "Express" destroyed part of the golf course and left cabanas strewn across the sand. Shinnecock Hills reached out to its Hamptons counterpart and welcomed Maidstone members at no cost. "A most friendly gesture," said the *Daily Eagle*'s Ralph Trost, "the likes of which this reporter doesn't remember having heard before." (Courtesy East Hampton Library, Long Island Collection.)

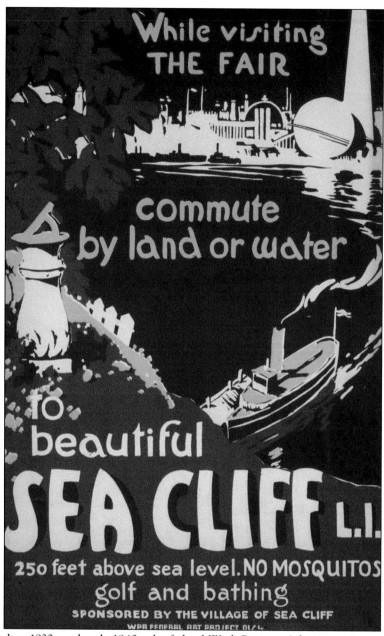

During the late 1930s and early 1940s, the federal Work Projects Administration put people to work creating thousands of posters promoting a variety of nationwide activities, exhibits, and programs. This 1939 poster touts the village of Sea Cliff as a recreational and golfing outpost for visitors to the World's Fair in Queens. In fact, Sea Cliff's golfing history was limited to a small period in the early 1900s. The short-lived Sea Cliff Golf Club was "no more" by 1903, according to the *New York Times*, since it only had enough land for six holes. Glenola Golf Club, described by the *Times* as "attractive and picturesque," featured nine holes overlooking the harbor in Sea Cliff, but it was gone by 1910. The poster likely refers to nearby clubs such as North Shore, Engineers, and Nassau, among others. (Courtesy Library of Congress, Prints & Photographs Division, WPA Poster Collection, reproduction no. LC-USZC2-5354.)

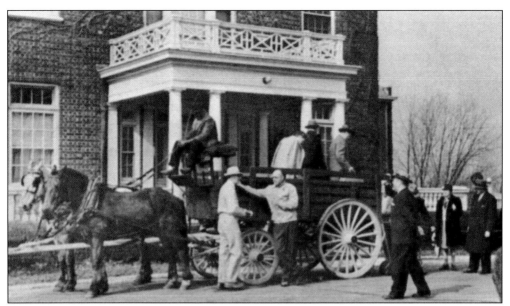

Clubs that did not benefit from trains delivering golfers to their doorsteps had to come up with other solutions during the wartime gas shortage. A local deacon drove a horse-drawn carriage, described in the Inwood Country Club's centennial book as "something between a tally-ho and a coal cart," to transport players on "gasless Sundays." "The travels of this equipage to and from the railroad station made a merry sight." (Courtesy Inwood Country Club.)

Inwood used its awkward yet effective carriage as the inspiration for its wartime newsletter. The pamphlet kept tabs on club members and their kin who were deployed around the country and overseas. "These are days when all of us are returning to the simple things . . . and liking them. Friends mean more. The Club means more. And the old gasoline-eater means less." (Courtesy Inwood Country Club.)

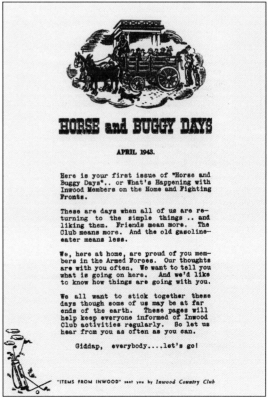

HORSE and BUGGY DAYS

APRIL 1943.

Here is your first issue of "Horse and Buggy Days".. or What's Happening with Inwood Members on the Home and Fighting Fronts.

These are days when all of us are returning to the simple things .. and liking them. Friends mean more. The Club means more. And the old gasoline-eater means less.

We, here at home, are proud of you members in the Armed Forces. Our thoughts are with you often. We want to tell you what is going on here. And we'd like to know how things are going with you.

We all want to stick together these days though some of us may be at far ends of the earth. These pages will help keep everyone informed of Inwood Club activities regularly. So let us hear from you as often as you can.

Giddap, everybody....let's go!

"ITEMS FROM INWOOD" sent you by *Inwood Country Club*

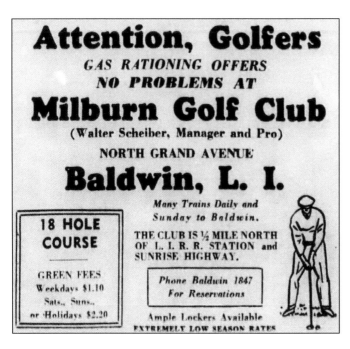

Attention, Golfers

GAS RATIONING OFFERS
NO PROBLEMS AT

Milburn Golf Club

(Walter Scheiber, Manager and Pro)

NORTH GRAND AVENUE

Baldwin, L. I.

Many Trains Daily and
Sunday to Baldwin.

18 HOLE
COURSE

THE CLUB IS ½ MILE NORTH
OF L. I. R. R. STATION and
SUNRISE HIGHWAY.

GREEN FEES
Weekdays $1.10
Sats., Suns.,
or Holidays $2.20

Phone Baldwin 1847
For Reservations

Ample Lockers Available
EXTREMELY LOW SEASON RATES

The Long Island Rail Road was a major selling point for courses in golf's early pre-automobile days, and it became a significant draw once again during World War II gasoline rationing. Baldwin's Milburn Golf Club sought to lure city golfers with the promise of an easy, gas-free commute. (Courtesy Newspapers.com.)

Milburn was able to navigate the early war years with relative success. The nearby train and the club's prime position along a bus route gave it an advantage amid gas rationing. New owners opened the formerly private club to public players, made improvements to the clubhouse, and added a 14-lane bowling alley. Shortly after the alley was built, however, a massive fire swept through the new facility and original clubhouse. (Courtesy Baldwin Historical Museum.)

Like Milburn, the Salisbury Golf Club used a nearby train stop to its advantage. Salisbury went so far as to modify the course setup to ensure that players saved not only gas, but also precious time getting to the opening tee. As the advertisement indicates, traditionalists could still choose to start from the clubhouse. (Courtesy *Newsday*.)

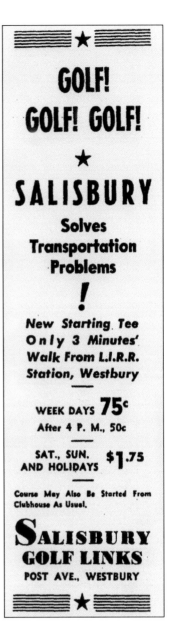

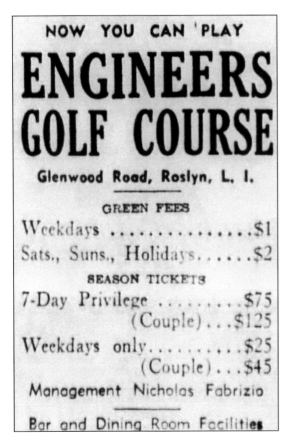

The notoriety that came with hosting the 1919 PGA Championship and the 1920 US Amateur did little to help the Engineers Country Club withstand the force of the Depression. In 1933, the *Brooklyn Daily Eagle* published a series of obituaries on the course. Yet, it managed to stagger forward; by 1938, it was a public course, and it would remain as such into the 1950s. (Courtesy Newspapers.com.)

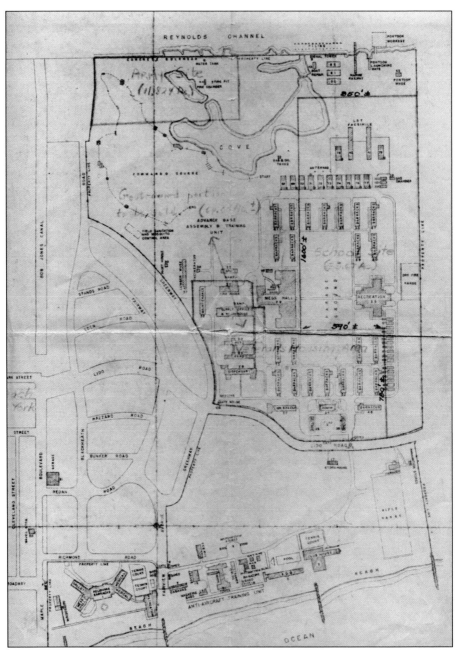

The Navy left no yard of the Lido Club unturned when it took over the grounds in 1942. The famous Channel hole launched pontoon boats in place of daunting drives. "Hope the Navy lads are enjoying it now," wrote *Newsday*'s Ed Buckley, longing for Lido's breezy layout amid a 1943 heat wave. Ralph Trost of the *Brooklyn Daily Eagle* simply hoped the Navy treated Lido with care. "War is serious business and war changes many things," Trost said. "But that can't stop a fellow from hoping that preparing Lido for the training of Navy men won't demand a complete leveling of the place. Because we're sure it would never come back." Trost's fears became reality after the war. The condition of the property, plus delays in reacquiring the entire parcel, led ownership to build a golf course on a new site to the east. (Courtesy Long Beach Historical Society.)

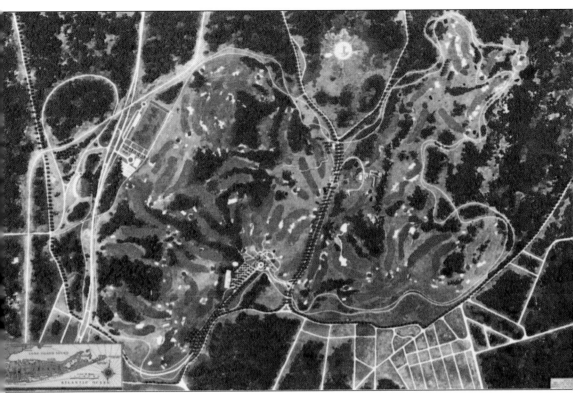

As the Depression weakened a host of clubs beyond the point of no return, the wheels were in motion to actually build a golf facility during a time of tremendous struggle. This particular facility would feature not 18, but 72 holes, all of them accessible to the public. Bethpage State Park, "The People's Country Club," was the product of a Depression-era public-works project that turned the former Benjamin Yoakum estate into a playground for golfers from all walks of life. This model of the facility depicted what, by 1936, became a fixture along the Nassau-Suffolk border: a giant golf complex consisting of the Green, Blue, Red, and Black Courses. Some of the features shown in this model were never built, including large sand traps right of the Black's opening fairway. (Courtesy Tillinghast Association.)

People's Country Club At Bethpage Park Now Has Four Golf Courses

Seventy-two Hole Links in Attractive Setting Radiate From Fine Clubhouse – New Course and Polo Field Open Today

The *Brooklyn Daily Eagle* announced Bethpage's full opening upon the Black Course's completion on May 31, 1936. "America's largest and most complete golf grounds are located at Bethpage State Park, nestling in a rolling wooded tract north of Farmingdale and bordering the village of Central Park," wrote the *Eagle*'s Vincent R. Kirk. (Courtesy Newspapers.com.)

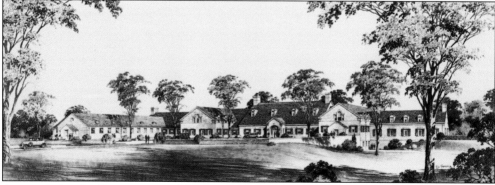

An artist's sketch offers a preview of the new Bethpage clubhouse, which opened with a dedication ceremony in August 1935. As many as 1,800 relief workers participated in the construction of the courses and clubhouse, according to *America's Linksland*. The tree-lined drive toward the clubhouse remains one of the iconic images of Long Island public golf. (Courtesy Tillinghast Association.)

Bethpage is forever linked to A.W. Tillinghast, the legendary designer responsible for much of the park's original concept. On top of the Black's international acclaim, Tillinghast's Red Course is often listed among the finest publicly accessible courses in the country. He worked elsewhere on the Island as well. His designs and renovations include Island Hills, Southward Ho, Hempstead, and North Hempstead. (Courtesy Phil Young.)

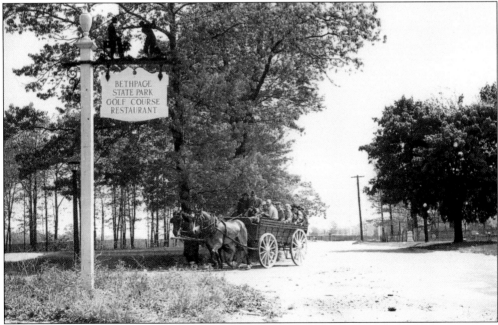

Golfers arriving at the Farmingdale train station during the park's prewar years were transported to the clubhouse by horse and carriage. The mile-long trip ended with a turn into the park along Quaker Meeting House Road. Today, 80 years later, the entrance looks similar, except for updated signs—and pavement. (Courtesy Tillinghast Association.)

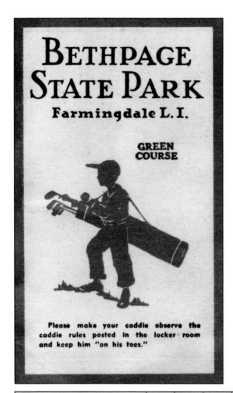

BETHPAGE STATE PARK
Farmingdale L. I.

GREEN COURSE

Please make your caddie observe the caddie rules posted in the locker room and keep him "on his toes."

The Lenox Hills Golf Club was already in place in Farmingdale when New York State went knocking at the Yoakum estate. Devereux Emmet guided 18 holes up, down, and around the hills east of Round Swamp Road in 1923. The *Brooklyn Daily Eagle*'s Ralph Trost wrote about the course's unique terrain: "We feel like Christopher Columbus this morning. Yesterday we discovered a central Long Island golf course which isn't flat." Part of the estate sale, Lenox Hills was state property by 1932, rebranded the Bethpage Golf Club, and opened to the public. Its new identity as the Green Course came a few years later. This scorecard reflects the routing sometime between 1936 and 1946, according to Bethpage historian Phil Young. (Both, author's collection.)

BETHPAGE STATE PARK | **GREEN COURSE**

Hole	Yards	Par	H'cap Strokes				+/−		Hole	Yards	Par	H'cap Strokes				+/−
1	351	4	9						10	333	4	12				
2	374	4	5						11	170	3	18				
3	122	3	17						12	293	4	14				
4	347	4	13						13	560	5	2				
5	372	4	7						14	348	4	10				
6	180	3	15						15	213	3	16				
7	502	5	3						16	363	4	8				
8	350	4	11						17	412	4	6				
9	552	5	1						18	400	4	4				
OUT	3150	36							IN	3092	35					
									OUT	3150	36					
									TOTAL	6242	71					

Date _____

Attest _____

Total _____ H'Cap _____ Net _____

Permitting faster golfers to play through makes your own game more enjoyable.

THIS CARD MEASURES SIX INCHES WHEN OPENED (STYMIE MEASURE)

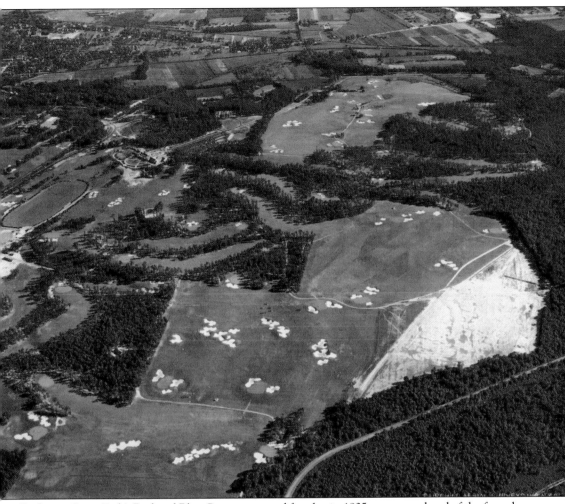

Bethpage State Park's Red and Blue Courses opened for play in 1935, one year ahead of the famed Black Course. This 1935 aerial photograph offers a rare look at the Bethpage complex in its infancy. The Red's tree-lined holes and expansive plain appear in the bottom half of the image, and in the background, the Blue follows its original routing, which would be heavily altered in the 1950s to make room for the Yellow Course. On the left side of the photograph, a polo field (with a match in session) occupies what soon became the Black's opening fairway. Construction of the Black Course is under way adjacent to the field. A new polo field would be built on the sandy expanse to the right of the Red Course. A segment of the Motor Parkway (bottom right) and the former Lenox Hills clubhouse (top left) are also visible. (Courtesy UCLA Department of Geography, Benjamin and Gladys Thomas Air Photo Archives, Fairchild Aerial Surveys Collection.)

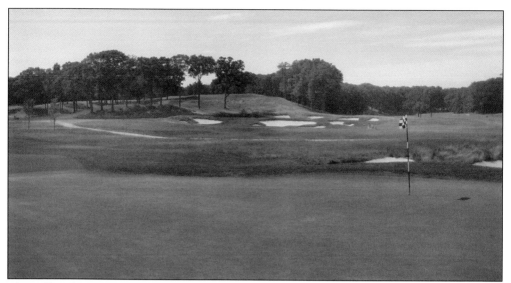

The still-undeveloped land near the polo field in the preceding aerial would soon become the site of some of the Black Course's final holes. The view of that area remained the same 75 years later. Looking from the first green, the heavily bunkered 17th green sits at the bottom of a hill that holds the 18th tee and Red Course's No. 4. (Author's collection.)

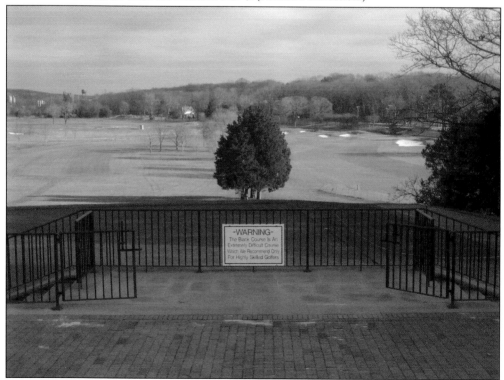

Bethpage Black achieved rock-star status after the 2002 US Open, thanks to the difficulty of the course, the boisterous, golf-crazed gallery, and its municipal identity. The "Warning" sign, clasped to a fence at the Black's first tee with the Bethpage valley in the background, became a celebrity as well. (Author's collection.)

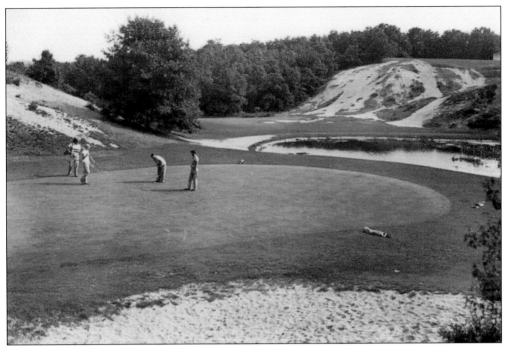

A group finishes out on No. 8 in this 1950s photograph. The hole's ragged look is tied to its closure during World War II. Several years of neglect left the Black and Blue Courses in terrible shape, according to Bethpage historian Phil Young. Maintenance in the years following the war was drastically cut so that park revenue could be used elsewhere. (Courtesy Tillinghast Association.)

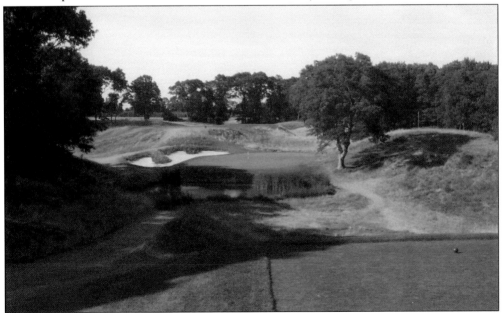

Nowhere is the elevation change at Bethpage as striking as the No. 8 tee on the Black Course. Hidden within the farthest reaches of the park, the par-3 welcomes players with a downhill drop to a green protected by the course's only water hazard—and a tree that slowly developed into more and more of an encroaching hazard with each passing season. (Author's collection.)

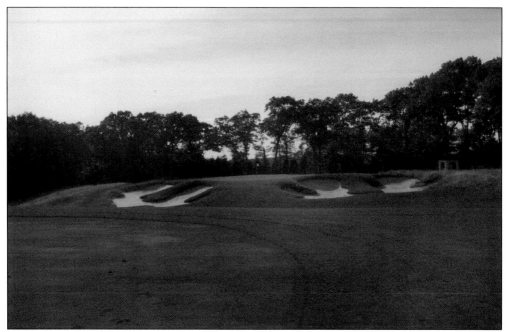

The 10th hole caused quite a stir during the 2002 US Open. The USGA set up the hole so that it required a 250-yard drive just to clear the deep fescue grass and reach the fairway. Luckily, only the world's greatest players were assigned that task. For amateurs, a greater issue is the expanse of heavy rough and deep bunkers that guard the green. (Author's collection.)

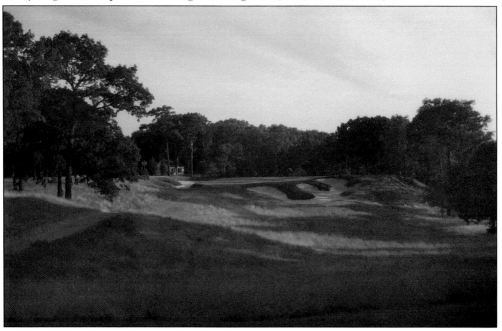

Rees Jones extended the front and back of the 14th green and added a sizable bunker in advance of the 2009 US Open. Like many par-3s at Bethpage, it plays over a gully. From there, the Black Course crosses Round Swamp Road and finishes on the clubhouse side of the park. (Author's collection.)

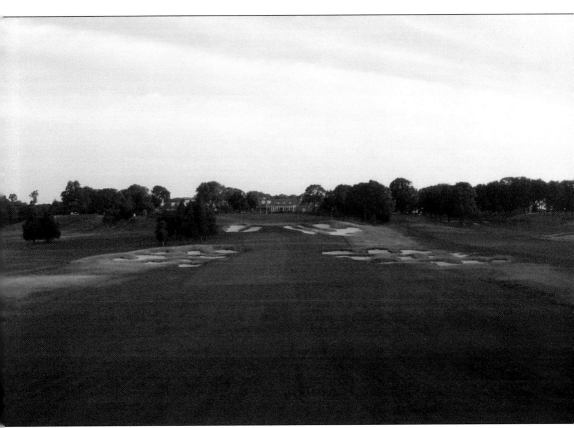

Tiger Woods and Lucas Glover completed their national-championship performances in 2002 and 2009 the same way thousands of amateur players finish up grueling rounds at Bethpage: on the Black Course's bunker-laden 18th. The clubhouse and green wait in the distance. Rees Jones lengthened the hole and redesigned the bunkers ahead of the 2002 US Open to alleviate concerns that the par-4 was too easy for professionals. Shortly before the 2009 tournament, in a piece titled "A Flat Finish," Ron Whitten of *Golf Digest* described the hole as "411 yards off an elevated tee to an elevated green, but all downhill in terms of excitement." Whitten said the USGA considered ways to bypass the hole, either by using the Red Course's 18th instead or by creating a temporary hole out of the Black's 18th tee, the Red's first fairway, and its stadium-style 18th green. (Author's collection.)

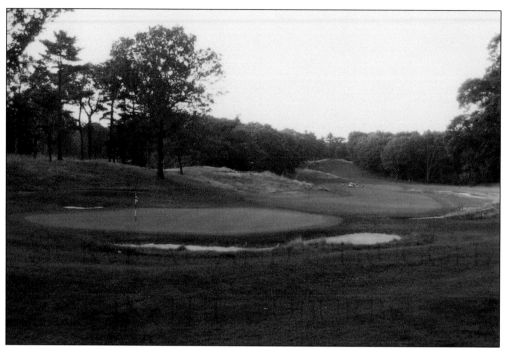

Bethpage's sloping terrain has always been a standout feature on the Red's 18th hole. Since its inception, the hole has changed little. As seen in this modern-day photograph, four bunkers and a steep, tree-shaded hillside surround its stadium green, setting the stage for a memorable and picturesque final approach—one that the USGA envisioned while considering 18th-hole options for the US Open. (Author's collection.)

The opening hole of the Green Course curves downhill to the bottom of the valley. Players on the first green can get a last look up at the clubhouse before crossing Round Swamp Road to carry out their round in relative isolation. The course does not return to the clubhouse side until finishing at the uphill 18th. (Author's collection.)

Four

SURVIVAL AND STRUGGLE IN THE SUBURBS

Long Island emerged from World War II with a new identity. Nassau County would never again be the "country." The figurative playground turned into a living room.

This posed a significant problem for the local golf industry. In order to accommodate the masses making their way east, homes needed to be built. The push for residential development consumed golf courses not equipped for the fight. Just over the Queens-Nassau border, homes took over the former sites of the Valley Stream Country Club and Woodmere's Cedar Point Golf Club on the south shore, and the Sound View Golf Club up north in Great Neck. Days were numbered for the Fresh Meadow Country Club in Queens, host of the 1932 US Open, so it bailed out of its Flushing home and jumped the Nassau border to take over the defunct Lakeville Club's course, where it remains today.

Roads were needed as well, and with Robert Moses at the helm, little if anything blocking the paths of new parkways would be spared. Deepdale Golf Club sat on land that Moses eyed for the Long Island Expressway. The club relocated just down the road, where its hilly new course would skirt the highway. Its old property, partially sheared by the expressway, became the remodeled Lake Success Country Club. A similar scenario played out in central Nassau, only, in this case, no remnant of the original course was salvaged. The Meadow Brook Club in Westbury occupied land directly between the Northern State Parkway and Jones Beach; connecting the two spelled doom for the longtime course. Meadow Brook built itself a new course in Jericho. The parkway that displaced it was named in its honor.

However, a funny thing happened along the drive east. Once the crowds of new residents settled into their suburban digs, suddenly, they needed more places to play golf.

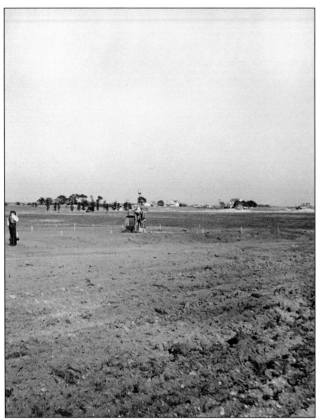

Central Nassau's landscape changed in a hurry in the years following World War II. Far removed from its days as the "Sports Center of America," Salisbury Golf Club was county-owned property for several years by the time fighting concluded, and two of its courses had been abandoned. In the late 1940s, construction crews worked to renovate the golf courses and transform the sprawling grounds into a recreational venue with widespread appeal. Salisbury No. 4, home of the 1926 PGA Championship, was the lone survivor. It was rebranded as the Red Course, and in 1951, Robert Trent Jones built sister courses for the park: the Blue and the White. (Both, courtesy Nassau County Department of Parks, Recreation & Museums, Photo Archives Center.)

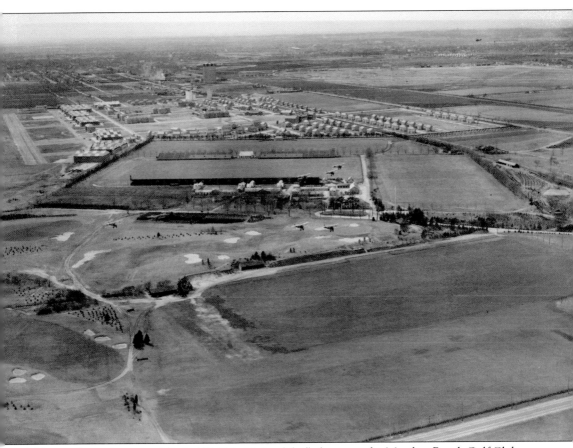

Military planes departing Mitchel Field in Uniondale fly low over the Meadow Brook Golf Club. Meadow Brook had been a sporting destination in central Nassau since the 1880s, and the golf course had been a fixture for four decades, but it could not survive the push for north-south roadways, especially ones that directed day-trippers to Jones Beach. The club was able to relocate to Jericho, but the course itself had no way to escape. By 1953, the land was in the hands of Robert Moses and New York State, and a long-discussed extension of the Meadowbrook Parkway was built through the heart of the property. Meanwhile, Dick Wilson's new course for Meadow Brook members opened in 1955 and would go on to host local tournaments and several LPGA and Senior Tour events. (Courtesy Howard Kroplick.)

The 6,450-yard Valley Stream Country Club opened in 1931, with advertisements billing it as "a superior course for the discriminating." This postcard looks south from the course grounds toward Colonial-style homes that still stand near the Southern State Parkway's entrance ramp at Franklin Avenue. A decade later, the club opened to the public, but it was gone by the end of the 1940s, the latest victim of residential development. (Author's collection.)

VOTE yes FOR THE KEYSTONE

TO OUR SCHOOL BUILDING PROGRAM THE GOLF COURSE SITE

The LAST Available Property Adequate to Meet the Known School Needs in Baldwin

BALDWIN HIGH SCHOOL AUDITORIUM
Tuesday, February 19, 1952
3:30 to 9:30 P.M.

Better Schools Mean Better Communities

Golf facilities could only resist so long until the push for more roads, more residences, and thus, more schools became too overwhelming. The Baldwin School District, eager to address concerns about overcrowded classrooms, had the 100-acre Willowbrook Golf Course (formerly the Milburn Golf Club) in its sights for several years. Finally, in 1952, the district acquired part of the property and built Baldwin High School. Many displaced Milburn/Willowbrook golfers moved on to become founding members of the Cold Spring and Pine Hollow clubs. (Courtesy Baldwin Historical Museum.)

Shelter Island golfers wanted an 18-hole course again. Beginning in 1950, the Shelter Island Lions Club raised money to resuscitate the long-neglected Manhanset layout. Here, Clark Bedford of the Lions Club unleashes an opening drive at the ribbon-cutting ceremony for the new Gardiner's Bay Country Club in August 1951. (Courtesy Shelter Island Historical Society.)

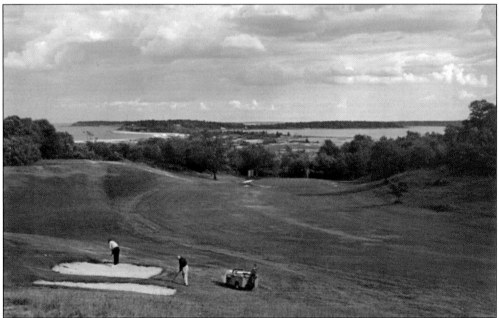

Whether the name was Shelter Island Golf Links, Manhanset, Dering Harbor, or Gardiner's Bay, the golf course occupying high ground between Greenport Harbor and Gardiners Bay always provided scenic water views. (Courtesy Shelter Island Historical Society.)

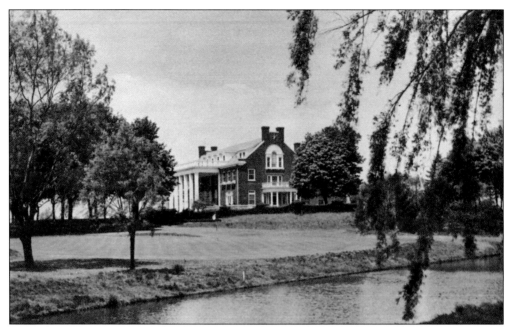

Inwood's clubhouse looms behind the 18th green in this 1951 photograph. The green is most often associated with Bobby Jones and his heroics in the 1923 US Open. The hazard fronting the green is known as "the Lauder." Sir Henry Lauder, according to club tales, dunked six balls in the creek and walked off the course. (Courtesy Inwood Country Club.)

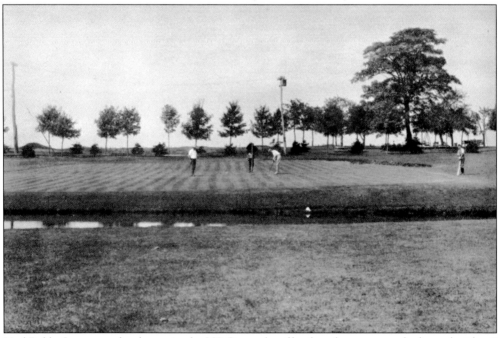

Had Bobby Jones opted to lay up in the US Open playoff rather than go over the hazard with a 2 iron, this would have been his approximate position on the third shot. Instead, Jones put his 2 iron only a few paces from the cup. Hordes of spectators, some standing near this spot on the fairway side of the hazard, then watched Jones win with a par. (Courtesy Inwood Country Club.)

Golf in Port Jefferson dates to the early 20th century. For a time, the area featured its original nine-hole course and an eighteen-hole Devereux Emmet design located side by side. Norman Winston purchased 600 acres of adjacent land for a real estate development in 1953 and hired Alfred Tull to combine the two courses into the 18-hole Harbor Hills Country Club, with a clubhouse showing off the modern stylings of the era. (Courtesy Incorporated Village of Port Jefferson Collection.)

Alfred Tull's 6,800-yard Harbor Hills course welcomed its first golfers in 1956. Though the course lives on today, its 1950s-era clubhouse was short-lived. A 1975 fire ripped through its dining, grill, and locker rooms. The Village of Port Jefferson purchased the course three years later and eventually rebranded it as the Port Jefferson Country Club at Harbor Hills. (Courtesy Kenneth Brady Collection. Now Property of the Village of Port Jefferson by gift of deed dated April 30, 2013.)

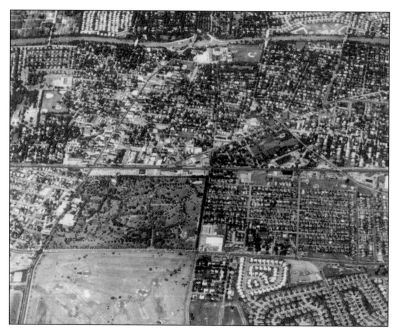

This aerial photograph, taken over Westbury, captures the northern end of county-owned Salisbury Park's Red Course. Today, tall trees line many of the Red's holes, but here, the course more closely resembles the Hempstead Plains on which it was built. (Courtesy Historical Society of the Westburys.)

Among the waterside amenities at Jones Beach State Park was a pitch-and-putt golf course, seen here in a 1960s postcard. Like any oceanside course, play was impacted by strong, frequently shifting winds. Unfortunately, it was also prone to saltwater flooding. The course was severely damaged by Hurricane Sandy in 2012 and never reopened. It is slated to become an "adventure park" as part of a Jones Beach renovation project. (Author's collection.)

Five

Long Island's Second Wind

From the mid-1950s to the early 1970s, dozens of golf courses, many of them open to the public, popped up across Nassau and Suffolk. Local government entered the fray, providing residents with tastes of waterfront play at the low cost of "muni" golf. The golf scene was revived.

Nassau County added three nine-hole courses to supplement the trio of eighteen-hole options already in place at Salisbury. Suffolk developed county-owned golf destinations in West Babylon, West Sayville, and Riverhead around the same time it acquired Timber Point, the former exclusive club on Great South Bay.

New private clubs opened their gates alongside Gold Coast and East End fixtures. The 1961 and 1962 seasons alone welcomed more than a dozen freshly seeded clubs, including Woodcrest, Cedar Brook, Old Westbury, Muttontown, North Hills, and Tam O'Shanter. Some never made it off the drawing board. A course called Forest Lakes was planned for Wantagh in the 1950s, but it never came to be. Others quickly stalled. Charter Oaks in Muttontown was billed as the next big thing, but it flopped.

Perhaps the most important figure of the era was William Mitchell. The Huntington-based designer laid out courses across Long Island, starting with the Pine Hollow Country Club in 1955. His résumé included clubs at Old Westbury and Noyac, but his focus was always on the public player. Suffolk County hired Mitchell to build its three new municipal courses and fit a nine-hole track (the White) into Timber Point. His design principles—subtly contoured greens, clearly visible bunkers, safe routes for average players—earned him the reputation as golf's "public defender," and many of those principles lived on through architect Francis Duane, whose public designs included Rock Hill and Merrick Road Park.

Mitchell bristled at the idea that public players should be left to play on "some kind of pasture." "Just because a man has to play a public course, why should he be marched around and regimented?" Mitchell said in a 1967 *Newsday* profile. "I don't see why a man's financial standing should have anything to do with his appreciation of a really good golf course."

"Vanderbilt Estate Now a Golf Course," read a full-page headline in the October 24, 1954, edition of the *Long Island Sunday Press*. Perhaps more noteworthy was the item written beneath: "First New Course in a Generation." William Mitchell completed the Pine Hollow Country Club in 1955 on the former estate of Consuelo Vanderbilt Balsan, ushering in a new wave of course-building around the Island. (Courtesy Pine Hollow Country Club.)

"As incredible as it seems," wrote John M. Brennan of the *Long Island Daily Press*, "the big estate at East Norwich known as Pine Hollow Country Club is a flourishing golfing layout." Just three years in, Pine Hollow hosted Long Island's first official PGA Tour event, the 1958 Pepsi-Boys Club Open. Arnold Palmer ran away from the rest of the field, while Bob Hope and a deep roster of celebrities entertained the crowds during pro-am play. (Courtesy Pine Hollow Country Club.)

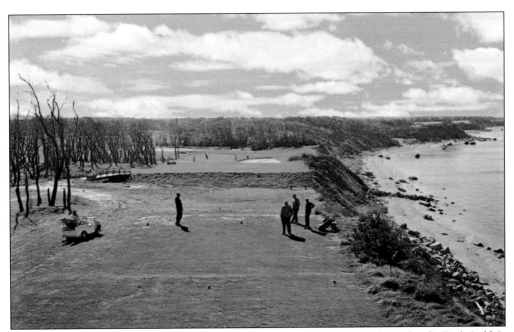

On an island filled with breathtaking golf vistas, the scenery offered at Island's End Golf & Country Club in Greenport is up there with the most memorable. The par-3 sixteenth hole, as seen in this 1960s postcard, plays atop a bluff that overlooks Long Island Sound. (Courtesy Southold Free Library, Whitaker Historical Collection.)

Short and to the point, this sign on the fence beside the tee asks players to avoid temptation and refrain from launching golf balls into the water while waiting to tee off on the 210-yard par-3. (Author's collection.)

At the same time that golf grew on the scenic waterside tips of Long Island, it expanded in the interior as well. A pair of 27-hole facilities were carved into the Middle Island woods in the mid-1960s. One, the aptly named Middle Island Country Club (above), sported three nine-hole tracks—Spruce, Oak, and Dogwood—routed on a former estate. Nearby, another course incorporated a large pond into its new design and titled itself the Spring Lake Golf Club (below). It featured an eighteen-hole "Thunderbird" course and a nine-hole "Sandpiper" layout, which allowed golfers little time to get their swing straight. The namesake lake forced a double water carry on the opening hole. (Both, author's collection.)

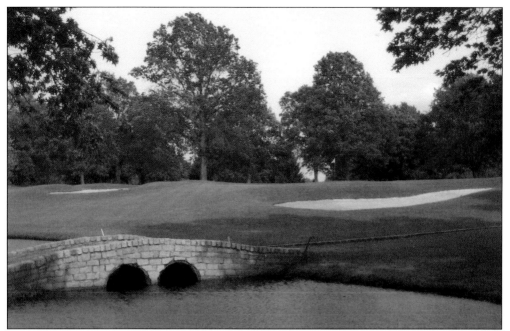

A small footbridge spans a water hazard in front of the 15th green at Eisenhower Park's Red Course. Renamed in honor of Pres. Dwight D. Eisenhower in 1969, the county-owned, 54-hole complex would likely have become the premier public-golf destination on the Island had it not been for Bethpage, down the road to the east. (Author's collection.)

When the Merrick Road Park Golf Course debuted alongside Merrick Cove, municipal golfers could enjoy exhilarating bay views similar to those found at ritzy clubs across the Island. In this photograph, taken from Merrick's second green, the bay is only steps away, and Jones Beach is visible on the horizon. (Author's collection.)

East Rockaway's Bay Park introduced the south shore bays and inlets to municipal golfers too, when it cut the ribbon on its nine-hole course in 1969. It was the third course to open in a Nassau County park in the 1960s. Hicksville's Cantiague Park and Roslyn's Christopher Morley Park, built on a former estate, preceded it. North Woodmere Park would later round out Nassau's nine-hole foursome. (Author's collection.)

Short courses popped up for beginners and beachgoers. The pitch-and-putt course at Cedar Beach featured 18 holes in quiet seclusion near the eastern end of Ocean Parkway. Back on the western edge of the parkway was the Jones Beach pitch-and-putt; across the canal to the east, a short course remains at Robert Moses State Park. (Author's collection.)

The Brentwood Country Club's presence in western Suffolk dates to the 1920s, when it was first sketched by Devereux Emmet. Brentwood went through a series of changes in its first few decades, many of which were overseen by resident pro Jack Sheridan. Legend has it that Sheridan and longtime playing partner Dan Healy faced off in a 1951 match at the club and set Brentwood's professional and amateur records in the process. Sheridan's birdie on No. 18, his 13th of the day, gave him the match and a professional record 59, one better than Healy's 60. Above, men's club president Dick McGuire (second from left) and fellow members pose with a Metropolitan Golf Association official (second from right) before the course went public in the early 1970s. McGuire helps out with course measurements in the below photograph. (Both, courtesy Brentwood Country Club.)

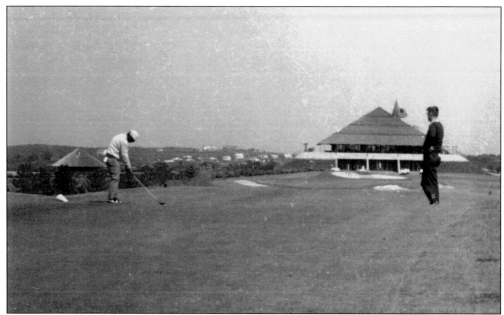

A golfer sends a shot toward the 18th green and the new clubhouse built in 1969 to replace the Colonial-style structure that long stood over Montauk Downs. Robert Trent Jones overhauled the Tippett course with the help of sons Rees and Robert Jr. The pyramid-shaped clubhouse, designed by Richard Foster, received an award for architectural excellence that same year. (Courtesy Montauk Library.)

In the 1930s, a peninsula along the Peconic River was the site of the world's largest duck farm. When the farm declined, according to *Newsday*, the Riverhead property transformed into a shantytown housing migrant workers. Seeking the land for new parks, Suffolk County began relocating the workers to safer conditions and bulldozing the grounds in 1964. Indian Island Country Club opened there less than a decade later. Its signature par-3 fifth hole features a scenic Peconic backdrop. (Author's collection.)

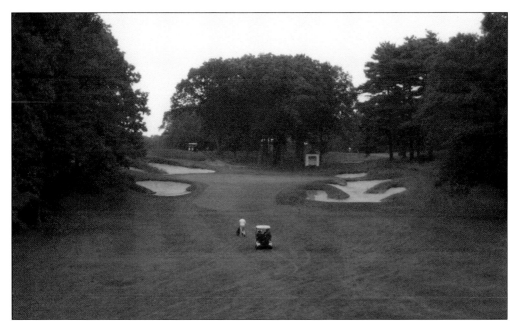

Alfred Tull's Yellow Course at Bethpage blended newly designed holes and parts of A.W. Tillinghast's original Blue Course. Under the new alignment, which debuted in 1958, the Yellow's back nine began with a series of Tillinghast holes that ended at the par-3 fourteenth hole. Players today can still easily differentiate between Tull and Tillinghast holes based on the varying size, style, and placement of bunkers. (Author's collection.)

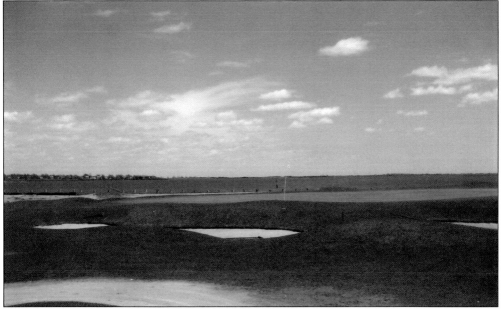

The private Middle Bay Country Club represented the modern era of golf in the south-shore village of Oceanside. Previously, part of the course and the school site to the north was home to the Oceanside Golf and Country Club, which was lost to development after World War II. Alfred Tull remodeled what remained of the course and stretched it out closer to the bay. (Author's collection.)

Please pay _before_ you play.

(in desk to your left)

Place green fees in envelope, fill out the front & drop into the slot in the door.

Sandy Pond does not have a glamorous backstory like many of its East End counterparts. The nine-hole par-3 course was built on top of an old Riverhead sand pit around 1970. However, it has long been a quaint oasis in the land of glitzy clubs, complete with a sign asking guests to leave payment in an envelope when the shop is empty. (Author's collection.)

The 1970s-era Sandy Pond course eventually fell into disrepair, with shrinking greens, dirty ponds, and an overgrown perimeter. New ownership took over in 2012 with a focus on restoring the natural look of the small course. Refurbished greens and the addition of fescue grass and landscaping immediately began attracting new players from the Riverhead area. (Author's collection.)

Solomon Guggenheim owned the estate that would eventually become the Village Club of Sands Point in 1994. It belonged to his brother Isaac Guggenheim until his death in 1922. The estate then became the IBM Country Club before the sale to Sands Point. (Courtesy Port Washington Public Library, Local History Collection.)

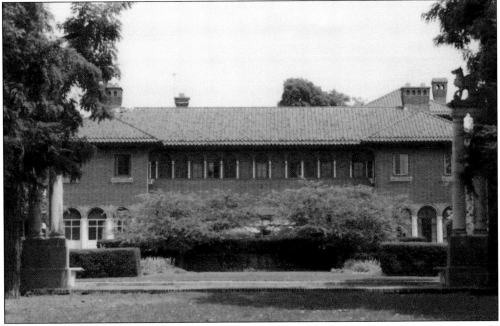

Built by Isaac Guggenheim in 1916 and known as Villa Carola, the Italian Renaissance-style mansion was renamed Trillora Court by Solomon Guggenheim, who had a nine-hole course built on the grounds. The mansion is still used today to host various club activities. (Courtesy Port Washington Public Library, Local History Collection.)

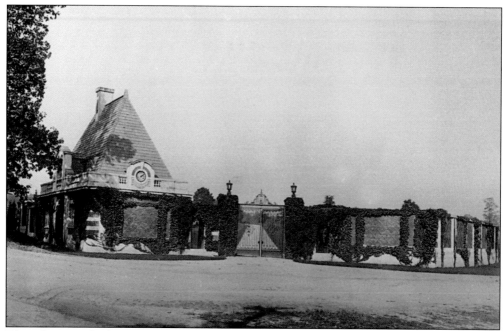

This photograph shows the gatehouse leading to the Guggenheim estate. After Solomon Guggenheim's death, the property was eyed for private residential development. When that fell through, it was purchased by IBM as a country club for its local employees. (Courtesy Nassau County Department of Parks, Recreation & Museums, Photo Archives Center.)

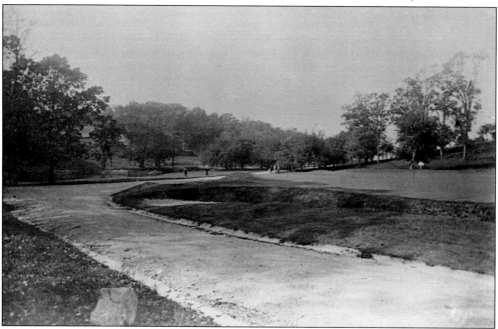

The Sands Point course is shown in this 1945 photograph. A major renovation in 2000 by Tom Doak included an overhaul of the original nine holes and an extension to an eighteen-hole layout. The course features views of Hempstead Harbor and the New York skyline. (Courtesy Nassau County Department of Parks, Recreation & Museums, Photo Archives Center.)

Timber Point was an exclusive, members-only club when it was completed by Harry Colt and Charles Alison in 1925. So protective of its privacy was the club, according to William Quirin in *America's Linksland*, that it refused a county effort to eradicate a mosquito invasion, because the bugs kept nonmembers far from the premises. When an estate next door was put up for sale, the club tried to block efforts to convert it to a public park. The centerpiece of Timber Point's golf course was a hole known as "Gibraltar," named for the prominent European rock. It is a par-3 with nothing behind its elevated green but Great South Bay. Fierce, shifting winds and sandy terrain made the long hole supremely difficult. It remains a nasty test as part of the county-owned Blue Course at Timber Point. The current 27-hole facility includes remnants of the original layout in the Blue and Red Courses; and an entirely new nine, the White, was added to the property by William Mitchell. (Author's collection.)

Another Timber Point original is the "Harbor" par-3. Now No. 2 on the Blue Course, the hole has forced players to execute a delicate shot over a hazard for more than 80 years. The green sits in a basin where the Connetquot River meets the bay. (Author's collection.)

The Harbor hole has long provided a distinctly maritime feel, thanks to the docks that stretch through the adjacent hazard. Short and long shots have a chance at finding the hazard. Bad misses to the left are lost either to the water or someone's yacht. It is a penalty either way. (Author's collection.)

Following Gibraltar, Colt and Alison forced players to battle overwhelming winds either off or toward the bay. It was not uncommon for players to aim their tee shots way out over the bay in hopes that strong gusts would carry them back to the fairway. The proximity to the bay has been both an attraction and a curse. This section of the course is vulnerable to storm surge, and it absorbed heavy damage during Hurricanes Irene and Sandy. (Author's collection.)

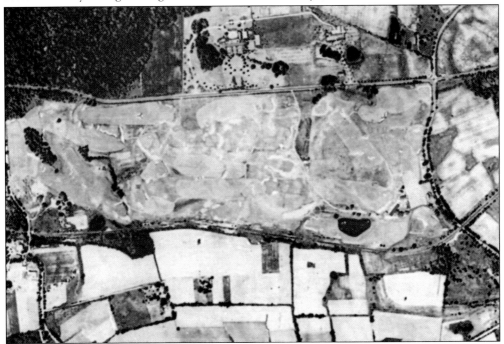

A course with roots as far back as 1919 lasted until the 1980s before giving way to residential development. The Links Club in Roslyn, seen here in a 1924 aerial photograph, was an extremely private facility. No photographs of the course were permitted, according to *The Evangelist of Golf: The Story of Charles Blair Macdonald.* It was designed by C.B. Macdonald. The property is now home to luxury housing. (Courtesy Howard Kroplick.)

The Town of Oyster Bay opened a municipal course on the grounds of the former Bruce estate, Woodlands, in 1989. Golfers lined up outside the gates in the wee hours on opening day to get first crack at Tom Fazio's challenging Woodbury design, which received rave reviews from players and local officials. Its signature hole is a dogleg par-4 with a fairway that rises 50 feet to a highly elevated green. Once they have crested the hill, players must navigate a three-tiered green. (Author's collection.)

Six

TOURNAMENTS AND EXHIBITIONS

Long Island hosted its first national tournament in an era when amateur play trumped competition between professionals. The 1896 US Open at Shinnecock Hills was essentially a short addendum to the US Amateur tournament, won the previous day over the same course by H.J. Whigham. Nevertheless, Long Island clubs continued to host US Opens and eventually PGA Championships. Within 30 years of the 1896 Open, 15 major amateur and professional tournaments were staged at seven different clubs. National Golf Links and Garden City also hosted early Walker Cup competitions between American and European amateurs.

Fresh in the minds of most fans are the two US Opens held at Bethpage in 2002 and 2009. The 2002 tournament was the first national championship ever decided at a public golf course, and the gallery showed its appreciation for the stars early, often, and loudly. Shinnecock returned to the Open rotation in 1986 after a 90-year break, then followed up again in 1995 and 2004.

In between those early tournaments and modern championships, Long Island built up a deep résumé consisting of PGA, LPGA, and Senior Tour events played and won by some of the game's greats. Arnold Palmer won the first PGA Tour event held at the Pine Hollow Country Club. Gary Player and Lee Trevino each won Northville Long Island Classics. The LPGA made an annual stop at Colonie Hill in Hauppauge.

This does not count all the local events—Met Opens, Met Amateurs, New York State Opens— that fill out Long Island's rich competitive history, or the exhibitions that pitted iconic golfers against one another. The list goes on, with no signs of slowing. In the next 10 years, Shinnecock will host another US Open (2018), while a PGA Championship (2019) and a Ryder Cup (2024) come to Bethpage.

Frances Griscom poses in front of the Shinnecock Hills clubhouse during the 1900 US Women's Amateur tournament. She defeated 16-year-old Margaret Curtis in the final, 6 and 4. While Griscom was "cool and careful" throughout the match, according to the *Brooklyn Daily Eagle*, "Miss Curtis went all to pieces and every weak point of her play came out." (Courtesy Southampton Historical Museum.)

Competitors in the 1913 Women's Metropolitan Golf Association Championship sit for a photograph at the Nassau Country Club. Marion Hollins of Westbrook beat Georgianna Bishop to win the event. (Courtesy Library of Congress, Prints and Photographs Division, reproduction no. LC-USZ62-121145.)

The second edition of what today is simply known as the PGA Championship was settled at the Engineers Country Club in Roslyn. Jim Barnes defended his title with ease, winning the final match 6 and 5 over Fred McLeod. The grand prize was $500, a diamond medal, and a silver cup for the winner's home club (McLeod netted $250 and a gold medal as runner-up). Spectators watched Barnes sink a number of lengthy putts and saw McLeod hole out an awkward approach from 80 yards. "Such performances are not everyday occurrences even on the easy courses," the *New York Times* explained. "It takes not merely professionals but top-notch professional linksmen to play such golf." (Both, courtesy the Bryant Library Local History Collection, Roslyn, New York.)

PROFESSIONAL
GOLFERS ASSOCIATION
of AMERICA

2nd Annual Championship
at Match Play for the
Rodman Wanamaker Prizes

ENGINEERS GOLF CLUB

ROSLYN, LONG ISLAND

September 16th to 20th, 1919

All matches at 36 holes

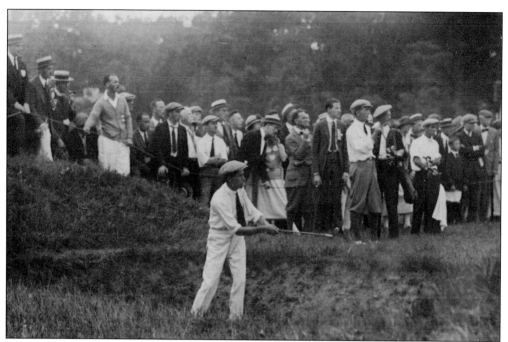

Jim Barnes escapes from a precarious lie during his 1921 "World Series" match with British Open champion Jock Hutchison at Great Neck's Sound View Golf Club. Barnes was once again victorious, not far from the site of his 1919 PGA triumph. Hutchison fell behind Barnes early and could not recover, ultimately losing the match 5 and 4. (Courtesy USGA Archives.)

Gene Sarazen (left) and Walter Hagen (right) came together for a photograph at the 1921 PGA Championship at the Inwood Country Club, though they would not meet on the course. Sarazen upset defending PGA champion Jock Hutchison in the second round before losing to Cyril Walker in the following match. Meanwhile, Hagen bounced Walker in the semifinals and defeated Jim Barnes 3 and 2 to capture the first of his five PGA Championships. (Courtesy Inwood Country Club.)

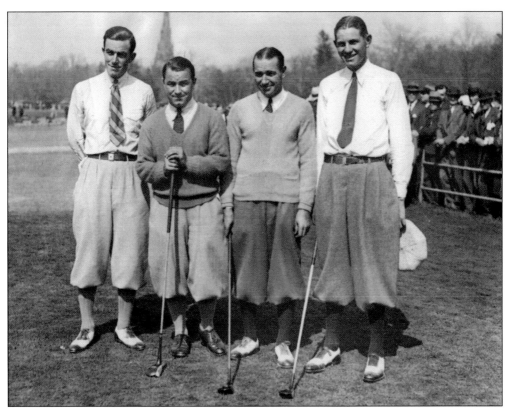

Members of the 1929 Ryder Cup team traveled the country, playing fundraising exhibitions before setting sail for Europe. The American teammates, shown here from left to right, are Johnny Farrell, Gene Sarazen, Leo Diegel, and Horton Smith. They entertained a local gallery with an 18-hole match at Garden City's Cherry Valley Club. Smith was the main draw, thanks to his seven early-season victories. (Courtesy USGA Archives.)

Sarazen demonstrates his swing in this 1922 photograph. He won his second US Open 10 years later at Fresh Meadow Country Club in Queens, where Sarazen had previously been the club professional. He moved to the nearby Lakeville Club prior to the Open to avoid jinxing his title shot. Ironically, Fresh Meadow would later take over defunct Lakeville's course in Lake Success when the club was forced to move east from Queens. (Courtesy Library of Congress, Prints and Photographs Division, reproduction no. LC-DIG-npcc-05944.)

Bobby Cruickshank's best chance to win a major tournament came in 1923, when the Scottish professional (pictured) tied young amateur Bobby Jones on the last hole of the US Open at the Inwood Country Club. In the next day's playoff, Inwood became associated with one of the most famous shots in golf history. Jones hit a 2 iron from the rough that cleared the lagoon in front of the 18th green and stopped only steps from the cup. (Courtesy Inwood Country Club.)

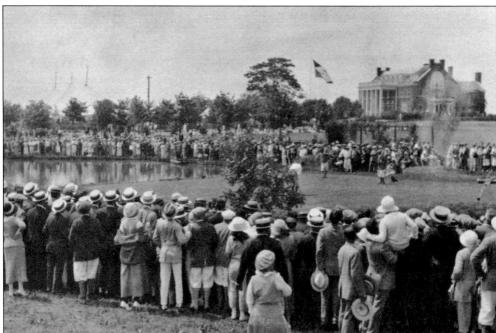

Bobby Jones (putting) and Gene Sarazen (leaning on club) line up putts on Inwood's 12th green as spectators strain for a clear view. Though Sarazen was no stranger to success at Inwood, he would finish far off the pace. (Courtesy Inwood Country Club.)

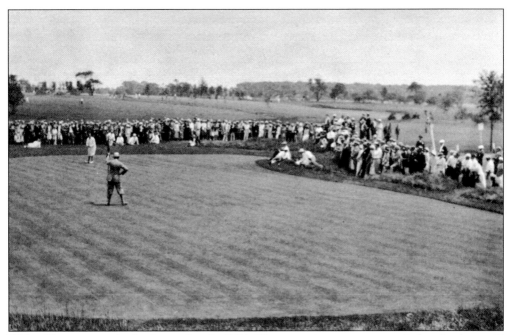

Walter Hagen triumphed at Inwood in the PGA Championship just two years before, but he could not duplicate those precise strokes during the Open and was not in contention. Here, Hagen and eventual runner-up Bobby Cruickshank putt on the 16th green. Cruickshank rallied to tie Jones in the final round to force a playoff. (Courtesy Inwood Country Club.)

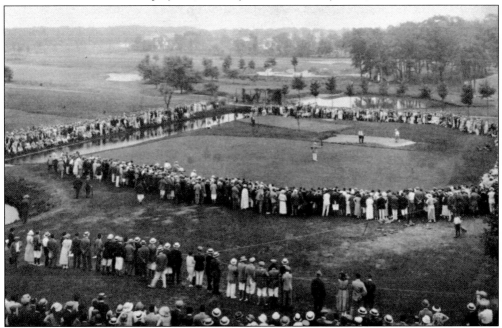

After Jones pulled off his incredible iron shot into the 18th green, Cruickshank was left to hit a memorable shot of his own. A poor drive and a layup left him in the middle of the fairway, and his desperate approach shot landed in a greenside bunker. Here, spectators surround the green and now-famous lagoon in the playoff's final moments. (Courtesy Inwood Country Club.)

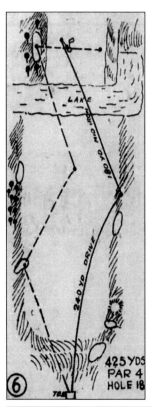

A sketch in the *Brooklyn Daily Eagle* on July 16, 1923, traces the winner's memorable route to the 18th green alongside Cruickshank's futile path. Cruickshank's topped drive into the left rough put him at a severe disadvantage. (Courtesy Newspapers.com.)

Johnny Fischer, seen here putting on the Garden City Golf Club's 18th green, defeated Jack McLean in the 1936 US Amateur. It was the fourth US Amateur decided at Garden City. Part of the tournament was played in torrential rain, though there were no postponements. Fischer injured an ankle trudging through a wet semifinal, according to *America's Linksland*, and he fell behind in the next day's match with McLean. He battled back to win on the first playoff hole. (Courtesy USGA Archives.)

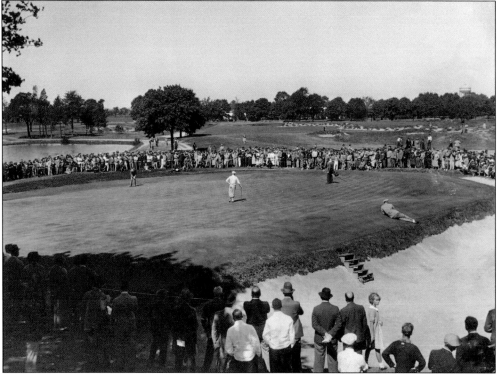

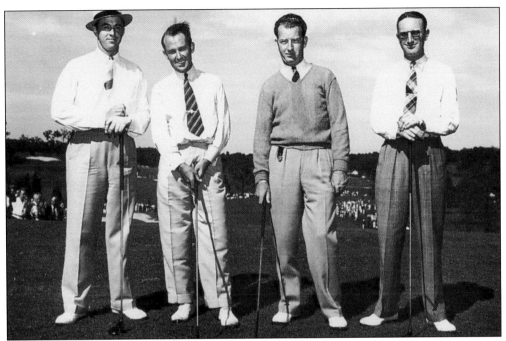

Shown here are, from left to right, Sam Snead, Paul Runyan, Jimmy Hines, and Al Brosch. They took part in an exhibition match at Bethpage Black in 1938. The foursome poses on the Black Course's opening tee. Snead would go head to head with Byron Nelson on the Black two years later. Admission to see two of the game's greats in action was 50¢. (Courtesy Tillinghast Association.)

Always a showman, Chi Chi Rodriguez entertains the crowd while on tee at the Northville Long Island Classic in 1992. The Puerto Rican fan favorite and his signature club-wielding histrionics were fixtures at the Meadow Brook Club in Jericho, which hosted the Senior PGA Tour event before it moved to Eisenhower Park's Red Course. George Archer won the 1992 tournament, the last of three consecutive wins in the event. (Courtesy Jim Torre.)

Corey Pavin entered the 1995 US Open at Shinnecock Hills in search of his first major championship title. He was three strokes off the lead heading into the final round, but he caught and passed leader Greg Norman on the back nine. Here, on the 17th green, Pavin had a chance to go two up with another birdie, but he would make a comebacker for par. (Courtesy Jeremy F. Kinney.)

Moments later, Pavin pulled off a dead-on Bobby Jones impression with his magnificent approach on the 18th hole. Leading Norman by a stroke, Pavin unleashed a 4 wood from well over 200 yards out that rolled to within five feet of the cup and reserved a spot in Open lore. His final-round 68 put him at even par for the Open, good enough for a two-stroke victory. (Copyright USGA/Robert Walker.)

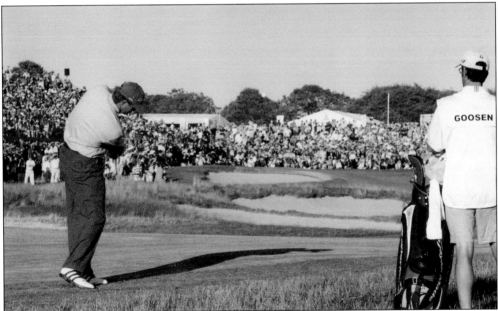

The US Open returned to Shinnecock Hills once again in 2004. Retief Goosen, seen here on his final approach, won a tournament remembered for the punishing course conditions, especially on Sunday. Putting greens rolled so fast due to heat and course setup that maintenance crews had to hose them down between groups. Phil Mickelson double-bogied the 17th hole on Sunday and lost to Goosen by two strokes. (Courtesy Jeremy F. Kinney.)

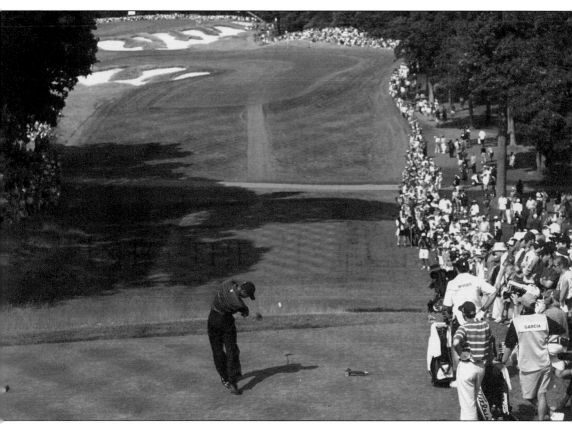

Bethpage Black's glacier bunker awaits Tiger Woods's tee shot during the 2002 US Open. Woods won by three strokes and was the only player to break par. It was this view that was partly responsible for Bethpage's entry into the US Open rotation, according to *Open: Inside the Ropes at Bethpage Black* by John Feinstein. USGA executive director David Fay walked around the course eight years earlier to either confirm or abandon his wild thoughts of the Black Course as a viable championship venue. Over time, the course had fallen into disrepair. Years of neglect and diverted revenue had eaten away at the bunkers, hardened the tees, and chewed up the greens. But the bones of the course were still intact; the Black just needed a makeover. This became clear to Fay as he turned away from the third green and approached the fourth tee. "That's when I knew," Fay told Feinstein. "Right there, it hit me." (Copyright USGA/John Mummert.)

Seven

INTO THE 21ST CENTURY

The dawn of the 20th century and the new millennium 100 years later shared the same rosy outlook about golf on Long Island. US Opens had been staged here in the not-so-distant past and would be hosted again in the near future. Demand for course construction was feverish in the early 1900s and high again in the 2000s.

The Town of Oyster Bay's municipal course jumpstarted a new wave of course construction; the anticipation surrounding its opening and the success that followed sparked new ideas about local golf design. Long Island golf's modern era was under way.

Another phenomenon helped spur development: Tiger Woods. His rapid ascent to the pinnacle of the sport seemed to coincide with the new Long Island boom. Waits on nine-hole munis were measured in hours, not minutes. Longtime and first-time golfers suddenly wanted to play on courses that looked like the ones Tiger dominated on television. New courses opened on top of an old sand mine (Harbor Links), a remodeled potato field (Long Island National), and a former sod farm (Tallgrass). Dozens of holes came to life at Mill Pond in Medford and Great Rock in Wading River. All of them were accessible to the public.

The 2002 US Open kept the flame burning and placed Long Island golf in the international spotlight. It was there again in 2004, when the Open returned to Shinnecock, and will be in 2018, when the Open is decided in Southampton once more.

All players checking in for a round at Eisenhower Park pass beneath a sign boasting of the facility's role in PGA Championship history. If they choose to play the Red, they will challenge much of the same course that Walter Hagen did in 1926. With the exception of new opening and closing holes, Eisenhower Red has stayed true to its original routing as Salisbury Golf Club's No. 4 course. (Author's collection.)

Environmental concerns were at the forefront of discussions regarding the future of an old sand pit near Hempstead Harbor in Port Washington. Some local officials supported building an incinerator. The Town of North Hempstead decided on a golf course instead. Michael Hurdzan designed the 27-hole Harbor Links Golf Course with the environment in mind, and the facility has been a member of Audubon International's Signature Program for much of its 15-year existence. (Author's collection.)

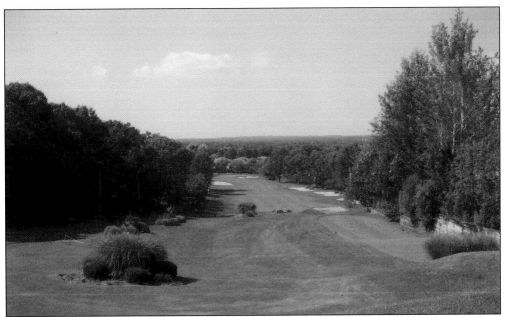

For a brief period, Colonie Hill in Hauppauge was at the top of the heap as one of Long Island's major social scenes, its elegant catering hall a magnet for international celebrities and influential politicians. Fittingly, the hall and its golf course sat atop one of Suffolk's highest peaks. But the sparkle faded amid financial issues, and the property was reinvigorated in 1990 with a hotel and the new Wind Watch Golf & Country Club. Its opening hole (now No. 10) offered a long-range view to the horizon before tumbling down the hillside. (Author's collection.)

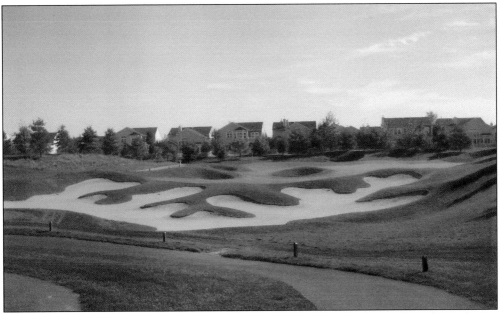

Stephen Kay amended the Wind Watch course in the mid-1990s. A decade later, he took on a bigger task farther east, in Mount Sinai. Kay designed a picturesque, Florida-style course called Willow Creek that featured nearly 100 bunkers, water hazards on 12 holes, and dramatically contoured greens. (Author's collection.)

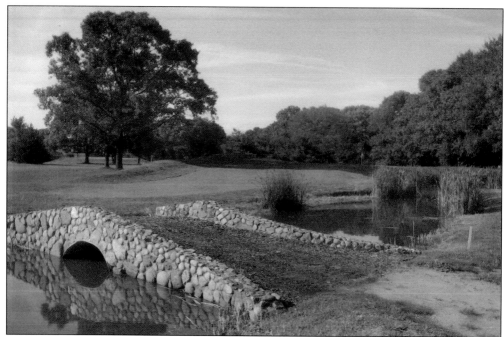

In 1999, the Hauppauge Country Club closed its doors and made way for Stonebridge Golf Links & Country Club, which opened the following year. Long Island's first new course of the 21st century was a throwback to the early 20th, its holes modeled after those crafted by Raynor, Macdonald, and Banks. Its namesake bridge crosses a small creek on the fourth hole, a "Redan" par-3. (Author's collection.)

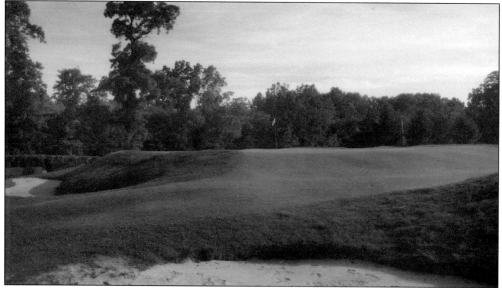

Stonebridge was George Bahto's first full golf-course design. Bahto, a Macdonald and Raynor expert and the author of *The Evangelist of Golf: The Story of Charles Blair Macdonald*, included other replicas like "Short," a tiny par-3 with a thumbprint ridge pressed into its green, and "Hog's Back," a challenging par-4 that culminates in a tricky green with a raised spine. Seen here is another famous design, the "Biarritz" seventh. (Author's collection.)

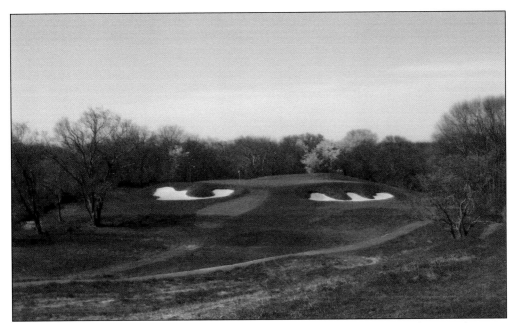

One byproduct of the US Open's success at Bethpage was the attention lavished on another state park, Montauk Downs. Following his work preparing Bethpage for the 2002 tournament, Rees Jones headed east to follow in his father's footsteps and restore Montauk Downs to past glory. Robert Trent Jones overhauled the Montauk original in 1969, with Rees at his side. The revamped 12th hole, a long and windy par-3, is Montauk's signature hole. (Author's collection.)

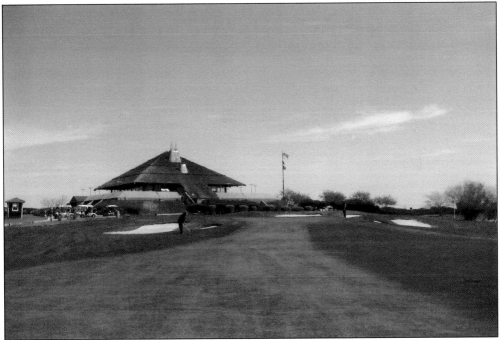

The view down the 18th fairway has not changed much at all in nearly 50 years. Weary golfers still finish wind-blown rounds in the shadow of Montauk's iconic 1960s-era clubhouse, with Rees Jones's reconfigured bunkers providing a modern element. (Author's collection.)

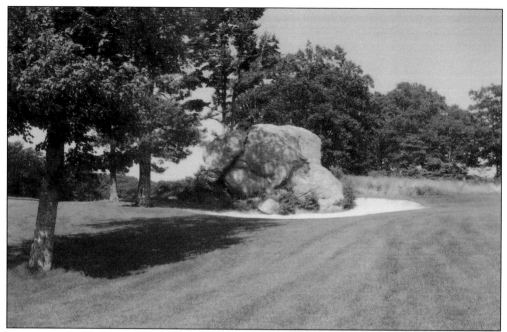

The namesake boulder at the Great Rock Golf Club greets players once they have completed the climb up the No. 10 fairway. Many giant rocks were unearthed when the Wading River course was built in 2001. The dramatic slope of the 12th green was partly attributed to the huge boulder found beneath its surface during a 2010 renovation. (Author's collection.)

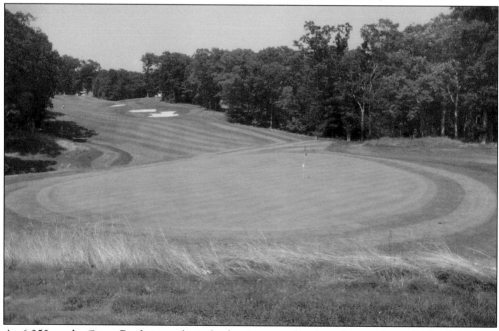

At 6,250 yards, Great Rock is a relatively short course, but it makes up for its lack of distance with big elevation changes and slick greens. Pictured here, the par-4 eighth rolls downhill before rising again toward an elevated flag. Ahead at No. 9, the tiered tee boxes provide scenic views to the south over the trees. (Author's collection.)

Around the same time Rees Jones was modifying and restoring the grandeur of Bethpage Black, his brother, Robert Trent Jones Jr., was out east, putting his own imprint on the Long Island golf scene. Jones Jr.'s Long Island National Golf Club replaced a former Riverhead potato farm with blustery, links-style holes. The course has since been converted into a private club. (Author's collection.)

The Bridge in Bridgehampton has a backstory unlike any other golf course on Long Island, as celebrated here on one of the club's scorecards. Rees Jones designed the course in 2002 over scenic, sloping terrain that was previously home to a racetrack. It features an ultramodern clubhouse and various ties to its racing past, including this overpass, which still spans the club's access road. (Courtesy the Bridgehampton Museum.)

Gil Hanse transformed a once-flat Shoreham sod farm into the sporty Tallgrass Golf Course in 2000. To create a course with undulations and elevation changes, Hanse dug out the center of the property and used the excavated material to build features around the course, leaving behind a canyon-style depression. Several holes play in and around this depression, including the par-4 eleventh. A sandy waste area guards the left side of the fairway, while a scruffy hillside and long, snaking bunker protect the right. (Author's collection.)

Tallgrass is named for the long, stroke-stealing fescue that borders many of its holes, but it also boasts a variety of expansive sand traps and waste areas. A few pot bunkers can be found on the course, including this one, an unfortunate landing area for an otherwise great tee shot. The bunker waits in the center of the ninth fairway. (Author's collection.)

Nassau Country Club will soon be celebrating 120 years as one of Long Island's most prestigious golf sites. The modern golf bag and clubs in this photograph offer a contrast with the stately brick clubhouse, which has been serving members and guests since 1910. (Courtesy Joan Harrison.)

Bellport Golf Club was partially redesigned and modified in the 1960s by Robert Trent Jones, and it has been rerouted as well since then. However, the course remains true to the original Seth Raynor design. Seen here is the final approach toward Bellport's clubhouse. (Photograph by Jim Krajicek, courtesy Incorporated Village of Bellport.)

The modern Lido Golf Club is not as revered by golf historians and architecture fans as is its barrier-beach predecessor, but that does not detract from its popularity. Lido, a Town of Hempstead municipal course designed by Robert Trent Jones, is typically jammed during peak season, thanks to its challenging, breezy layout that leads players right up against and along Reynolds Channel. (Author's collection.)

Jones tipped his cap to C.B. Macdonald when he built the new Lido by including a replica of the old "Channel" hole. The updated par-5 includes two watery routes to the pin—one dangerous, the other very dangerous. It concludes at a green just steps from the bay, setting up picturesque putts, whether they are for birdie or quadruple-bogey. (Author's collection.)

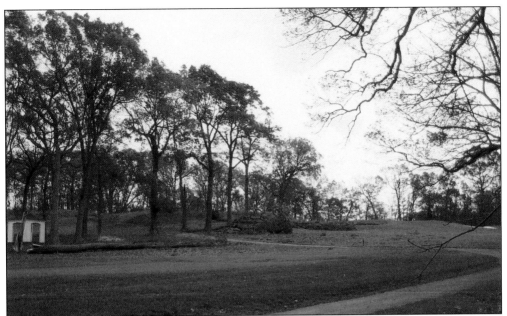

Old, stately trees at Bethpage State Park (above) and Bay Park (below) were no match for Hurricane Sandy's brute force. The 2012 storm brought down large trees all across Bethpage, including these giants on the third hole of the Green Course. Low-lying courses along Long Island's south shore suffered tremendous, nearly catastrophic damage during the hurricane (and a snowstorm that followed). Lido Golf Club was partially submerged by ocean and bay waters. Displaced boats were scattered at the Rockaway Hunting Club, where the halfway house bears a line nine feet off the ground to note the floodwater's peak. Timber Point's bayside Blue Course, which absorbed heavy blows in 2011 from Hurricane Irene, sustained even more significant damage during Sandy and remained closed for eight months. At Bay Park, debris from the adjacent docks crashed through the course's perimeter fence. More debris littered the fairways and greens. (Both, author's collection.)

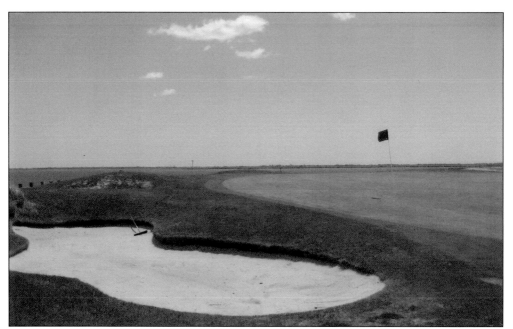

Middle Bay picked up the torch from the defunct Oceanside Golf & Country Club during the second golf boom and offered scenic bayside golf to members. The club was a casualty of Hurricane Sandy, but again, the torch was passed to not only keep Oceanside golf afloat, but also to offer it to public players. Despite saltwater flooding, equipment loss, a destroyed clubhouse, and more than $3.5 million in total damage, the Oceanside golf course reopened the following spring as the semiprivate South Bay Country Club. Members and public players had access to waterfront holes, including its signature par-4 eighth, where a sandy waste area fronts the bayside green. Ownership changed after its initial season, but public play continued at the picturesque course, this time renamed The Golf Club at Middle Bay. (Both, author's collection.)

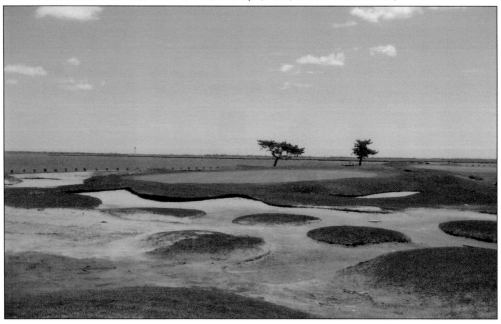

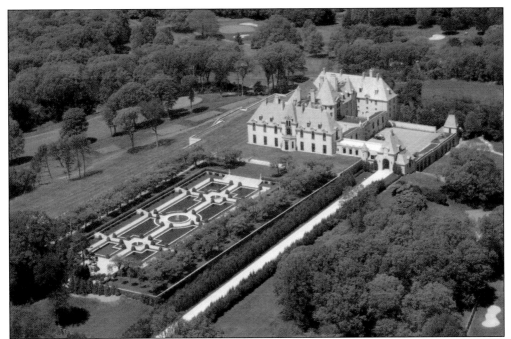

Oheka Castle and its adjacent golf course underwent significant changes after Otto Kahn's death. The castle's history was tumultuous, including a lengthy period as a military academy, years of heartbreaking decay, and, eventually, a luxurious revival. Meanwhile, Kahn's golf course continued to circle the sprawling grounds. It became the Cold Spring Country Club in the 1940s; Robert Trent Jones redesigned Seth Raynor's original in 1968. Cold Spring surrounds Oheka in this modern-day aerial photograph. (Courtesy Oheka Castle.)

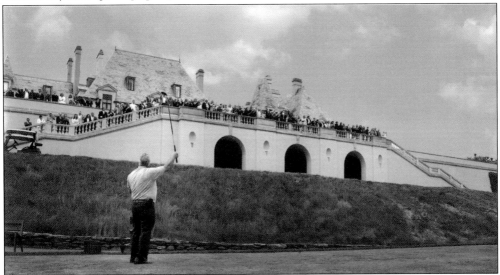

Despite historical and geographic ties, Oheka and Cold Spring did not operate as partners. The Kahns' 1940s sale effectively ended the relationship between castle and course, until the two were brought back together in 2009. Nearly a century after Kahn's initial shot on his home course, Gary Melius, Oheka's owner since 1984, took a ceremonial swing to launch a new alliance that would make the golf course available to Oheka guests. (Courtesy Infinity Photography.)

A. W. TILLINGHAST
"TILLIE"

DEDICATED BY THE GRATEFUL PEOPLE OF THE STATE
OF NEW YORK ON OCTOBER 2, 2000, IN APPRECIATION
OF HIS BRILLIANT DESIGN OF THE BLUE, RED AND
BLACK COURSES AT BETHPAGE STATE PARK. THE BLUE
COURSE OPENED FOR PUBLIC PLAY ON APRIL 28, 1935,
THE RED COURSE ON MAY 30, 1935 AND THE BLACK
COURSE ON MAY 30, 1936. MILLIONS OF GOLF ROUNDS
HAVE BEEN PLAYED ON THESE GREAT LAYOUTS BY
GENERATIONS OF PUBLIC GOLFERS AT BETHPAGE,
"THE PEOPLE'S COUNTRY CLUB."

REES JONES
"OPEN DOCTOR"

DEDICATED BY THE GRATEFUL PEOPLE OF THE STATE
OF NEW YORK ON OCTOBER 2, 2000, IN APPRECIATION
OF HIS BRILLIANT PRO-BONO RENOVATION OF THE
BLACK COURSE DURING 1997-1998 IN PREPARATION
FOR THE UNITED STATES OPEN CHAMPIONSHIP.
THE BLACK COURSE RE-OPENED FOR PUBLIC PLAY
ON JUNE 9, 1998. SINCE THEN, PUBLIC GOLFERS
HAVE BEEN TESTING THEIR SKILLS ON THE BLACK
WHERE THE WORLD'S FINEST GOLFERS WILL TEST
THEIRS IN "THE PEOPLE'S OPEN," IN 2002.

Facing Bethpage Black's famous warning sign is a large rock with two plaques embedded in its face. The plaques honor two designers who left huge imprints on Bethpage itself, as well as on Long Island's golf landscape as a whole. A.W. Tillinghast and Rees Jones took part in distinct transformations that were separated by decades but ultimately had the same result: providing all Long Island golfers with public courses they could be proud to play. (Author's collection.)

BIBLIOGRAPHY

Bahto, George. *The Evangelist of Golf: The Story of Charles Blair Macdonald*. Chelsea, MI: Clock Tower Press, 2002.

Feinstein, John. *Open: Inside the Ropes at Bethpage Black*. Boston: Little, Brown and Company, 2003.

Quirin, William. *America's Linksland: A Century of Long Island Golf*. Chelsea, MI: Sleeping Bear Press, 2002.

——— and the Metropolitan Golf Association. *Golf Clubs of the MGA*. Golf Magazine Properties, 1997.

Wexler, Daniel. *The Missing Links*. Chelsea, MI: Sleeping Bear Press, 2000.

DISCOVER THOUSANDS OF LOCAL HISTORY BOOKS FEATURING MILLIONS OF VINTAGE IMAGES

Arcadia Publishing, the leading local history publisher in the United States, is committed to making history accessible and meaningful through publishing books that celebrate and preserve the heritage of America's people and places.

Find more books like this at
www.arcadiapublishing.com

Search for your hometown history, your old stomping grounds, and even your favorite sports team.